Wisconsin's Rustic Roads

A Road Less Travelled

Introduction and Photographs by Bob Rashid • Foreword by Clay Schoenfeld

Text by Bill Stokes, Ben Logan, George Vukelich, Jean Feraca and Norbert Blei

Published by Lost River Press, Inc. • Boulder Junction, Wisconsin

Other books by Lost River Press:

Harvest Moon: A Wisconsin Outdoor Anthology

Written by contemporary writers who sensitively relate their special bonds with the diverse landscape of Wisconsin, and how the outdoors has shaped their lives, thoughts and personal relationships.

The 26 pieces collected for this book, each by a different Wisconsin author are, as the title implies, a harvest, a gleaning of evocative stories, soliloquies and essays celebrating Wisconsin. Here are selections from such notable late authors as Aldo Leopold, Gordon MacQuarrie, Dion Henderson and Mel Ellis, along with current writings from such prominent personages as George Vukelich, Justin Isherwood, Dan Small and Clay Schoenfeld. Less well-known but highly gifted authors are included, too, some of whom are published for the first time in *Harvest Moon*. Collectively, all these authors' works reflect what the harvest moon traditionally symbolizes; a coming together of people at harvest time to venerate life and the fruits of the earth.

Hardcover, $19.95 224 pages, 26 line illustrations

ISBN 1-883755-00-X

To Order, call 1-800-366-3091

Dedication

For my parents

Irene and Bob Rashid

And for my friend and partner

Marilyn Holly Cohn

For more information,
contact the publisher at
Lost River Press, Inc.
P.O. Box 620
Boulder Junction, WI 54512

**For a free color catalog
of other Lost River Press
outdoor and nature titles,
call toll free at 1-800-366-3091.**

Photographs
© 1995 Bob Rashid
Madison, Wisconsin

Edited by
Greg Linder Editorial Services
Boulder Junction, Wisconsin

Designed by Mary A. Shafer
Production by
The Art Emporium
Milwaukee, Wisconsin

ISBN 1-883755-02-6
Printed in USA

**Library of Congress
Cataloging-In-Publication Data**

Stokes, Bill, 1931-
 Wisconsin's rustic roads:
a road less traveled/intro. and photographs by Bob Rashid; text by Bill Stokes … [et al.].
 p. cm.
ISBN 1-883755-02-6 (hc)
1. Wisconsin–Description and travel.
2. Rural roads–Wisconsin.
3. Wisconsin–Guidebooks.
4. Landscape protection–Wisconsin.
5. Automobile travel–Wisconsin–
 Guidebooks.
I. Rashid, Bob, 1949-.
II. Title.
F586.2.S76 1995
917.7504'43–dc20 95-14187
 CIP

Wisconsin's Rustic Roads

A Road Less Travelled

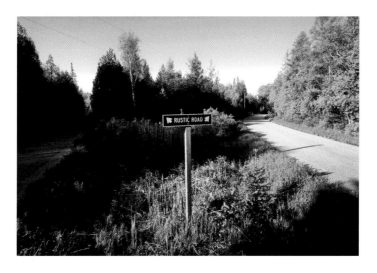

Introduction and Photographs by Bob Rashid • Foreword by Clay Schoenfeld

Text by Bill Stokes, Ben Logan, George Vukelich, Jean Feraca and Norbert Blei

Published by Lost River Press, Inc. • Boulder Junction, Wisconsin

Table of Contents

Publisher's Note

Every so often, a publisher gets the chance to create a really special book. Some confluence of circumstances arises that allows the talents of many people to come together to form a work that is so unique, so fresh, that even the story of how such a work came to be is, in itself, a point of interest.

Wisconsin's Rustic Roads is such a book, and I'd like to share with you the history of its existence.

It began with the vision of one man, photographer Bob Rashid. At the time, he thought he was embarking on a simple exercise in photographic practices; he wanted to become a better photographer, and thought the state's Rustic Roads would be pleasant subject matter for his lens. After all, they wound through the many geographies and landscapes of our diverse state, and would provide ample visual variety throughout the changing seasons.

What resulted at the end of his odyssey, however, was much more than a few pleasant images. Bob discovered, as he spread out the multitude of slides before him, that what he had inadvertently done was capture the very essence of the Rustic Roads system; he had documented the successful results of one of the nation's most forward-looking preservation programs. There, on film, the beauty of the roads themselves proved the wisdom of their existence. Our cultural heritage was there, ever so subtly, in every image. Each photograph was a visual celebration of our vast cache of natural resources.

He understood then that he needed to get these photos out to a wider audience so that others might come to appreciate the precious gift our legislators had given us – and all those who would come after us – with the inception of the Rustic Roads program. Bob began searching for a publisher who would be interested in his body of work and his ideas.

At the same time, I was looking for a strong project that would continue to establish Lost River Press as a different kind of nature and outdoors publisher; one that, along with championing the theories of responsible environmental management and interaction, also celebrates actual situations in which these ideas are successfully implemented in "real life." It was during one of my reveries on this subject that I received Bob's initial call concerning his idea. In retrospect, I can see a pattern of this kind of magic at work throughout the entire process of creating this book, and I can't help but smile.

After several discussions on how we would approach and present the subject matter, we drew up a contract and set to work to actually produce the book. Having agreed that the photos, although striking in and of themselves, would benefit from some accompanying text, we worked out a writing approach that was as loosely structured as the photographic process had been. Dividing the state into five general geographic regions, we asked five of Wisconsin's best known writers each to contribute an essay on what the Rustic Roads of a particular region meant to them. We sent the individual authors to explore the roads in their given territory throughout the year. To give the

book an added charm, but not wishing to overpower the visual imagery, we gave no instructions or guidelines to the writers except to write about whatever it was that particularly moved them about their travels. It was these original views that we would pass on to you, the reader.

It was a gamble. Rarely does such an uncontrolled effort by so many different people like this result in a work that is cohesive enough to hold together within the scope of a book. Even anthologies about similar subjects often threaten to come apart at the seams, held in place only by rigorous editing and an overpowering design structure. But this approach, like Lost River itself, was an idea whose time had come. The subject matter and the ideas it embodies were strong enough to provide a foundation solid enough to build upon. We decided to go for it.

Our faith was amply rewarded. What emerged was quite a remarkable product. Unique, personal thoughts and common threads from the writers wove Bob's brilliant imagery into a loose, delicate fabric of rural, natural and cultural history that spoke in a quiet, eloquent voice from every page. You hold in your hands the final result of this labor of love, and we hope you will treasure this book and enjoy paging through it time and again as much as we enjoyed putting it together for you.

David Personius
Publisher, Lost River Press

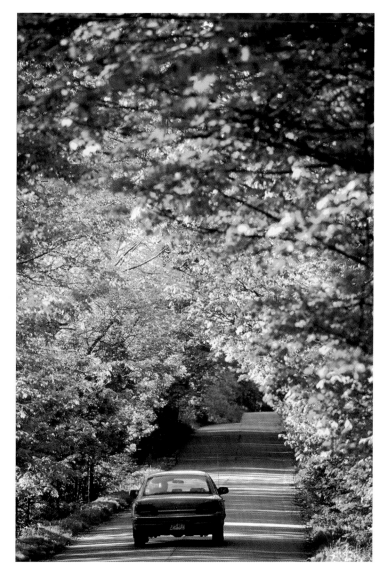

Rustic Road 44, Marinette County.

Acknowledgments

For the two years I worked on this project I was extremely fortunate to have been helped by many people whose kindness and generosity I will always remember.

Had I not studied with Chuck O'Rear at a photographic workshop in Santa Fe in 1992, I may never have had the idea or the courage to persist on this course for so long. Not only did Chuck teach me more about lighting in one week than I ever dreamed possible, but his constant encouragement inspired me to work toward an end that I could not foresee. My intention when I first set out to photograph the Rustic Roads was simply to grow as a photographer. Chuck's vision was certainly clearer than mine.

Jane Carrola, coordinator of the Rustic Roads program, was an invaluable source of answers to my innumerable questions, and I could not have started this project without her assistance. The same can be said for Ernie Stetenfeld, editor of *AAA World*, whose suggestions helped get me going. Magazine editors John Fennell and Sharon Nelson of *Milwaukee Magazine* and Nancy Mead at *Wisconsin Trails* stood behind me after seeing only a tiny sample of the work, and their trust was absolutely essential to my being able to continue shooting. To them I owe a great deal.

Kathleen Iattarelli, who contributed to this project in many ways, along with Nancy Ragland helped me pursue a grant from the Wisconsin Arts Board. The grant was used to mount an exhibition of prints that traveled to galleries around the state for a year and a half, exposing many people to the importance of preserving the Wisconsin landscape through programs like the Rustic Roads, and providing the inspiration for this book. Steve Agard and Linda Pearson helped make that exhibit successful, and I am also indebted to Jeannie Dosch for her help with the initial publicity.

I am grateful to the Olbrich Botanical Gardens, Madison; The Rodman Center for the Arts, Ripon College; Miller Art Center, Sturgeon Bay; The Neville Public Museum, Green Bay; University of Wisconsin Hospitals, Madison; Center for The Visual Arts, Wausau; The Mosquito Hill Nature Center, New London; and The Mode Theatre, Waterloo, for exhibiting the work.

One spring afternoon I gave my mother and stepfather, Irene and Ken Lay, a ride down Rustic Road 22 because they were curious about what I was up to. From that day on they became two of my greatest supporters. Their generosity was unequaled and they did everything in their power to keep the project moving. Additional help came from a former high school classmate, Doug Kelm, who piloted the plane that took me over Door County. I also want to extend a special word of thanks to David Sparer, Jim and Lois Errington, and Lillian Jahnel, all of whom went out of their way to help make this book possible.

Many personal friends helped me more than I'm sure they realize. I would like to thank Ron McCrea, Jerry and Lauri Neiber, Peg Scholtes, Dr. Ed and Pixie McCabe, Paul and Dorianne Gitlin, Ruth Gitlin, Dan and Susie Piorier, Steve and Andrea

Steen, Bill and Katherine Bender, and Al and Barb Dykema. A special thanks to Mike Olson and Stacy Gold at Hyperion for handling my film with such tender loving care. Additional thanks goes to the staff at Burne Color Lab.

Through the efforts of television producer Joanne Garrett and senior videographer Chuck France, a story about this project aired on Wisconsin Public Television in 1994, and a documentary about the Rustic Roads and the making of this book is being filmed for 1995. I have been particularly pleased because it has allowed me to go on the road with my good friend Chuck France. We spent many memorable hours filming the Rustic Roads together and now we know all the best cafés in the state. Incidentally, our field guide was the book *Café Wisconsin,* which I keep permanently in my car next to *The Gazetteer.* I want to thank Joanne Raetz Stuttgen for doing such great culinary research.

It has also been my pleasure to work with the creative people at Lost River Press. I have come to admire and respect publisher David Personius, editor Greg Linder and designer Mary Shafer on both a professional level and a personal one. I could not have asked for a more comfortable atmosphere in which to work. I am particularly grateful to David for everything he has done and continues to do.

I would also like to thank the contributing writers who have added a wonderful dimension to this book. It was a special treat for me to visit the North Country with longtime friend George Vukelich, and also to read Jean Feraca's moving piece about the Old Marsh Road after hearing her so often on Wisconsin Public Radio. I was honored to meet Ben Logan and Norbert Blei for the first time, having known them through their many books, and I've always held Bill Stokes' writing in the highest esteem. To work with these exceptional people has been a tremendous experience.

Throughout all of this I would have been lost without the friendship of Holly Cohn whose ideas, energy, warmth, sense of humor and creative drive have become an integral part of my life. Her contribution touched every aspect of this book and, believe me, we should all be thankful for that.

About This Book

This map shows the geographical landscape characteristics of the state of Wisconsin to give you an idea of the diverse natural areas through which the 67 official Rustic Roads wind, so that you might form a better mental image of these areas as you read the essays in this book.

Dotted lines indicate the areas covered by each author's essay: Bill Stokes ruminates on the roads of southern and southeastern Wisconsin; Ben Logan details those along the state's western boundaries. George Vukelich reflects on the Rustic Roads that carry their travelers through Wisconsin's Great Northwoods; Jean Feraca muses about those that wind their way through the state's central, sandy regions; and Norbert Blei contemplates the Rustic Roads of Wisconsin's easternmost reaches. 🖋

Wisconsin's Varied Landscape

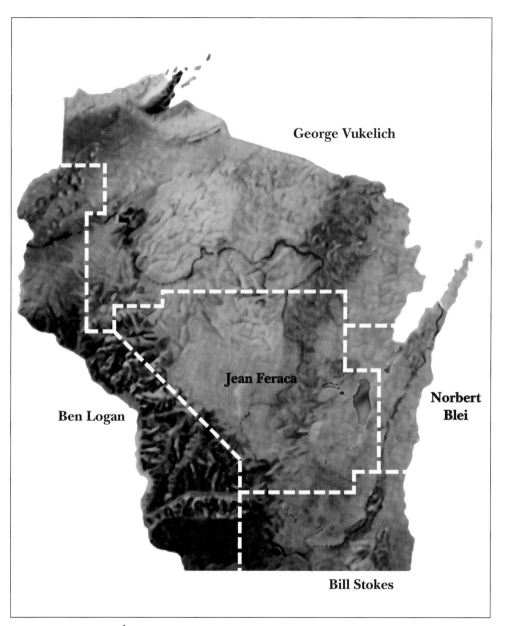

George Vukelich

Norbert
Blei

Jean Feraca

Ben Logan

Bill Stokes

Foreword

by Clay Schoenfeld

Love of rustic roads seems to reside eternal in the breasts of Wisconsin Badgers.

About 40 years ago, when I was a young UW faculty member moonlighting as a weekly outdoor columnist for the (Madison) *Wisconsin State Journal,* I wrote a Sunday offering one April called "Sideroads to Somewhere." It started out like this:

Any day now, the swallows will swarm back to their mud apartments on the side of the red barn at the northeast corner of County Trunk BB and State Highway 73 on the eastern edge of Wisconsin's Dane County.

A natural phenomenon such as this packs as sure a message of resurrection as do Easter sermons. But you can't " hear" these important outdoor messages if you stick to the I-highways. To keep track of Spring's return you have to sacrifice speed for scenery and take the sideroads.

The popularity of that column prompted a 1966 book, *Wisconsin Sideroads to Somewhere,* and then a 1979 sequel, *Down Wisconsin Sideroads.*

It is with those credentials that I'm proud and happy to welcome the newest recruit to the genre, **Wisconsin's Rustic Roads,** a glorious assemblage of magnificent color portraits by a remarkable photographer, together with moving interpretive essays by five of the state's best-known writers.

It takes time, this wandering around on sideroads, but the investment is worth it. Driving from Madison to Milwaukee, for instance, you can skip I-94 and take BB from Blooming Grove through Cottage Grove to Lake Mills and beyond. You won't get to Milwaukee so fast or so smoothly, but you'll see those swallows — and a lot of other signs of a countryside of good will.

A Wisconsin Pulitzer Prize-winner of another era, Zona Gale, once championed the advantages of "a serene sideroad existence." What she was saying was an echo of Henry Thoreau:

I yearn for those old, meandering, dry, uninhabited roads which lead away from towns ... where you may forget in what country you are traveling ... by which you may go to the uttermost parts of the earth. It is wide enough, wide as the thoughts it allows to visit you.

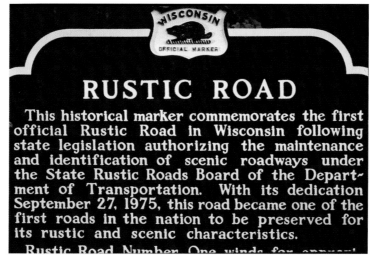

Historical Marker, Rustic Road 1, Taylor County

Few of us would choose, in these challenging times, an isolation like Thoreau's, living apart in the cabin he built himself at Walden Pond. Fewer of us still will have the courage or the genius to make of such a career an immortal success. It is well, then, in our crowded and distracted days, to listen to Thoreau's words. He reported from his out-of-doors that he "heard no bad news." We can hear the same trouble-free message down Wisconsin's rustic sideroads today. ♠

Introduction

by Bob Rashid

When I was a child growing up in the '50s, my parents would take us out in the family's Studebaker Lark for drives on Sunday. It was the custom then, at least in the area around Ripon, Wisconsin, to tap your horn lightly before you passed someone, as a courtesy, to let the person know you were about to swing by on the left. More often than not, the person being passed would acknowledge the courtesy with a wave or a smile. My father, never one to be in a hurry, was usually the one passed, so our family did a lot of waving and smiling.

In the fall we stopped to collect hickory nuts that had dropped by the side of the road. Sometimes we found apple trees. Whenever geese flew overhead we pulled over to watch and listen, our heads poking out from all the open windows like little birds ourselves, straining to get a better view. My mother often packed picnics: lemonade, and a mixture she called ground meat, made from ring bologna, dill pickles, and mayonnaise, ground together and spread on white bread, making a sandwich I still must have when I go home for a visit. Then there was the ice cream at Pickett's gas station, where they gave out generous portions for a nickel—a bargain even then. I was always amazed at how quickly my father could eat an ice cream cone and never let it drip while he was driving.

I don't recall everything we did; it all happened a long time ago. What remains in my memory is a very pleasant feeling. It was a time when falling asleep on the backseat of the car and being carried in the house to bed was one of life's great pleasures. There was a sense of security associated with the drives, and an innocence that only the very young are allowed to know.

My father has been dead now for over twenty years. A

lot has changed in those two decades. In Wisconsin alone there are a half million more people. Cities have swelled out to where the countryside used to be. Our pace of life is immeasurably faster. Interstate highways run like arteries, pumping people to their destinations at frantic speeds. "Sunday driver" is a term of derision. You honk now to get someone going, and you are likely to incur that person's wrath.

About the time my father died, Earl Skagen, then a highway commissioner for Racine County, was driving to work each morning along his favorite road—Maple Lane near Burlington. Skagen could see where the future was headed, at least as far as roads were concerned. He understood the kind of "progress" that bulldozes everything in its path to clear the way for what is to come. That was his job. But, he thought, what a shame if a road like Maple Lane lost its trees and its little pond so that someone could shave a few minutes' time off the way to work. Skagen became an activist, and through his efforts the Rustic Roads Board was created by law, and the Wisconsin Rustic Road system came into being.

During the system's 22 years of existence, 67 roads have been officially designated, thus assisting their preservation. During the past two years I have been driving and photographing them. I've visited all 67 roads, many of them several times. In the process, I've clocked more than 15,000 miles and shot some two hundred rolls of film. It has been an extremely pleasant experience for me. It has allowed me to slow down and relax, and to see parts of Wisconsin that I would have never known existed.

I've found that I like being out early in the morning, when everyone else is asleep. In the moments around sunrise, the sky, in the direction opposite the sun, turns an incredible shade of blue. The color is not duplicated for the rest of the day. If you miss it at sunrise, it's gone.

Standing by the side of a Rustic Road at that time of

Forty years ago
I could have been
on this road with my parents.

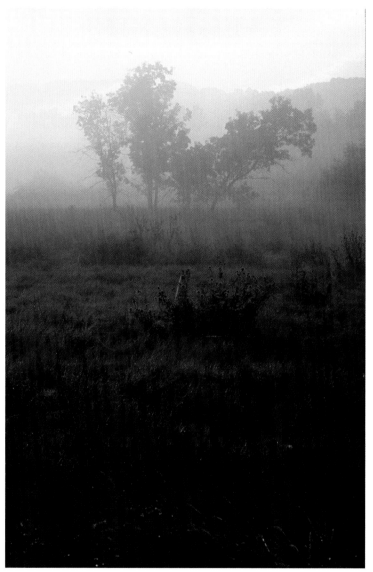

Sunrise, Rustic Road 4, St. Croix County

day, I hear the birds sing. The sun breaks the horizon and the dark landscape is immediately painted with orange light. Forty years ago I could have been on this road with my parents. It would have looked very much the same. I watch and I listen, and scamper back and forth changing lenses and worrying about exposure settings. Caught between nature and technology. One day I'll find myself on a Rustic Road without a camera. With no shutter in front of me, everything is likely to be clearer. ♣

Rustic Roads

by Bill Stokes

Old roads gossip. They pass along secrets about where lovers park and which settlers sleep the long sleep in country churchyards and who lives on the homesteads now. Their spectral voices rise like family whispers, hushed and confidential; the traveler who pauses to listen is caught up in the sweet harmony of nature and time.

In the befuddled tongues of creation, the old roads speak of ancient trysts in glacial beds, when earth and ice were newlyweds and the land was shaped in a geologic passion. The remnants of those voices cling to the steep slopes and the sprawling prairies like the relentless mewing of the ages, and written into their rhythm is the soft shuffle of those first, tentative human footsteps. They followed the game trails among the mountains of melting, dirty ice; and these courageous forays of fight and flight

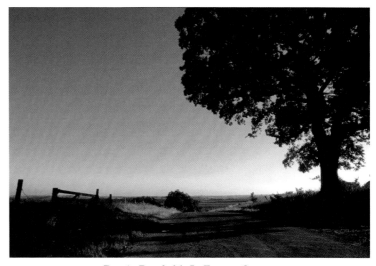

Rustic Road 66, LaFayette County

were the genesis of the Rustic Roads as surely as the meltwater laid out the rivers.

So it is necessary to traverse the old roads like the deer and the bear—slowly, cautiously, and forever alert for predators. The grand ambush for human travelers lies in the insidious ego that encourages us to ignore the Earth's cycles and deny our place within them. We practice our best denial on the big racetrack highways, where metal and

concrete carry us like mind-less, streaking robots. After so much of that, we must come to Rustic Road places to resurrect our spirit and to regain our sanity.

The scream of a red-tail hawk spears down from the top of a towering hill in

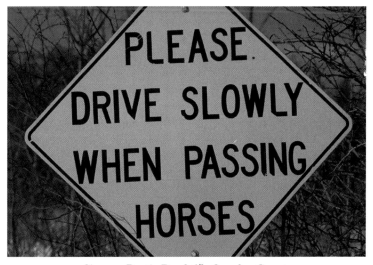

Sign on Rustic Road 65, Ozaukee County

Odd voices speak when the gentle roads take us on leisurely detours.

There may be special added value to the old roads in the more popu-lous southern portions of Wisconsin. Here the rat race is cranked up to

the Kettle Moraine area. Its sharpness hangs over the winding road like a shriek from a pulpit, and in its way the hawk preaches as authoritatively as the nearby spires of Holy Hill: "But for a little twist in the evolutionary trail, I might have been a snake instead of a hawk. We have the same eyes, you know."

But for another twist, the fuzzy hair on human arms might have been feathers, and we might have soared over the serpentine roads with the hawk.

Andretti levels, and the usual pit stops are little more than grab and gobble affairs in our pedal-to-the-metal lifestyles.

That point is powerfully made if you careen off Interstate 94 and head north on Highway 67. Within min-utes and just a couple of miles, you are on the Rustic Road that winds through the woods between Upper and Lower Nashotah Lakes, past the sprawling grounds of Nashotah House Seminary. The contrast is striking, like stepping from a riot to a waltz.

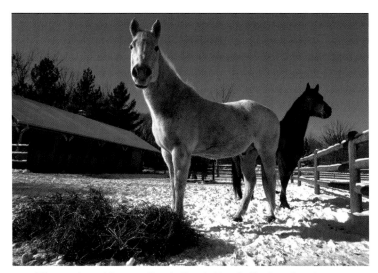

Horses along Mequon Road, Rustic Road 65, Ozaukee County.

"This is a beautiful place," says Father John Obokech, a student at the seminary, as he strolls beneath the trees not far from the road. "It puts you so close to nature and so far away from the stresses of the city."

Amen, Father.

Within the guileless piety of those Rustic Roads near population centers, horses now stand as peculiar symbols of cultural distillation. Their predecessors came here to power the first dirt scoops and graders as the trails were converted to early roads. Then they strained to pull plows that cut the prairie sod and took families to town and to church in buggies and wagons. They were essential, important; and those of us with memory long enough know that in their big, wonderful dumbness, the utilitarian horses exuded a quiet confidence.

Now their descendants, lighter of flesh and limb, stare immobile from behind the white fences along the back roads; and if they had enough collective intelligence to pose a question, it might have to do with the meaning of such a leisurely life. It is a question perhaps contemplated most effectively by those retired travelers who seem to predominate on the back roads, where the tempo is down and delightful.

"Please drive slowly when passing horses," says a sign on a Rustic Road near Mequon. It might be edited to add: "and when passing retired people."

The Mequon road is one of the last gravel surfaces in the southeast part of the state, and rural mail carrier Sue Seaberg says, "It's a pain when it rains and gets muddy, and I hate all the dust when it's dry." So the endorsement of everything that goes with Rustic Roads is not unanimous.

Way down in the southwest corner of Wisconsin, between Hazel Green and New Diggings, Conrad Harker lives along one of the roads that winds through some of the old lead mining country.

"They ran over one of my coyote hounds a while back," Harker says. "I had at least $350 in food and shots in that dog."

There is too much traffic on Rustic Roads, Harker says; but it is, of course, all relative. On one of the more heavily traveled roads near Burlington, William Whitten says, "When we first moved out here in '86, there was hardly any traffic. Now, with all the big new houses being built, the road is like a freeway."

Ah, yes. The big new houses. Nothing threatens the character of many of the old roads in the southeast like the housing developments that gobble up fields and woodlots with such a voracious appetite.

Those factors that give the roads their special character are, of course, what many people seek for the site of their dream home. And they are building their homes

Fence and tree on Rustic Road 33, Washington County.

everywhere, some of them standing like angular glass castles on the hilltops that overlook the marshes.

"I don't know where all the money comes from," says Whitten.

It has ever been thus. People with enough money to do so have claimed for their own many of the places of natural beauty. On a Rustic Road that loops along the north edge of Lake Geneva, the lake is hidden behind the wooded grounds and imposing entry gates of plush estates. They were developed by the likes of the Wrigleys from Chicago many years ago, so the filing of personal claims on nature's jewels is nothing new. But now it seems to be happening along some of the Rustic Roads to a jarring degree, emphasizing the fact that so little area remains untouched by our desires and ambitions.

There are alternatives to building something new in order to live along the special old roads, and one involves restoring an old, original farmhouse.

"We've been working non-stop on this house for the past two years," says Gaye Bowers as she pauses from washing the windows of the unique stone home that she and her husband Bob own on Oak Knoll Road north of Burlington.

"It's the Jedick Healy home, and it's on the Historic Register," Bowers says. "We just love the place."

That affection is obvious in the careful attention to authentic detail, including the small, round stones that make up the house's distinctive front and the precise dental molding around the inside rooms.

Another way to live along the roads is to remodel one of the old one-room schoolhouses. Their box-like construction is unmistakable at many rural intersections, and the joyous voices of country kids echo up out of the weedy ditches if you are so ancient as to date back to the era of the one-room school.

But, while some of the Rustic Roads are burdened

e practice our best denial on the big racetrack highways, where metal and concrete carry us like mindless robots. After so much of that, we must come to Rustic Road places to resurrect our spirit and to regain our sanity.

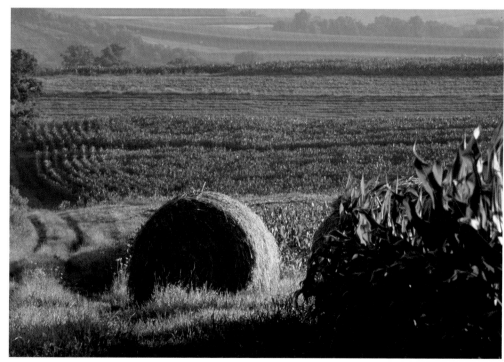

Baled hay and cornfields along Beebe Road, Rustic Road 66, LaFayette County.

with more "civilization" than seems appropriate, nature inevitably adjusts and accommodates, so all is not lost in the vicinity of the population concentrations. Deer snort from landscaped backyards, just as they snort from the untamed thickets. Coyotes howl along suburban edges. Hawks soar over the pastures where the horses wait. And beaver build dams on the straightened streams.

There are, in fact, many miles of Rustic Roads in southeast and southern Wisconsin where breathtaking views conjure up the old, groaning glacial voices. There are many more miles where rolling fields blend with river bottoms and woodlots to present bucolic vistas that seem to produce whispered exclamations from the country churchyards.

On a Rustic Road just south of Madison, there is an old field that has reverted to big bluestem, a tall, delicate, native grass that once covered vast prairies. No matter the season, the wind speaks exquisitely there of time and cycles.

Then, on a starlit night along one of the old roads near Milton, the rural darkness is like the sudden lifting of your skull to expose the senses in a rare manner. The imagination, conditioned by miles of Rustic Road travel, is also freed from the constraints of reality. In the night, the voices became a chorus. Deep geologic rumbling. Muted chanting around ancient campfires. Mumbled prayers of sturdy settlers. Soft plodding of spectral horses.

Then the spell of the transcendental symphony is broken by the immutable blowing of a nervous deer from a darkened ravine. Some voices and some things never seem to change along the old roads; and that, in the final analysis, may be the crux of their charm. &

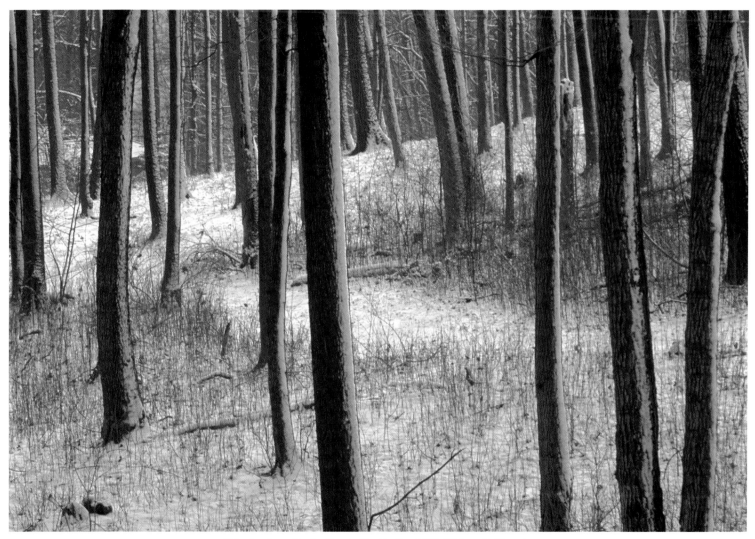

Woods along Snake Road, Rustic Road 29, Walworth County.

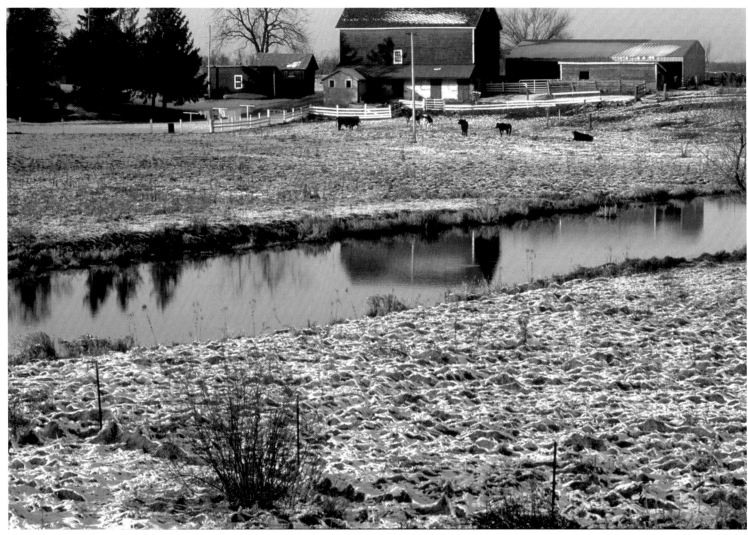

Farm along Rustic Road 27, Winter, Green County.

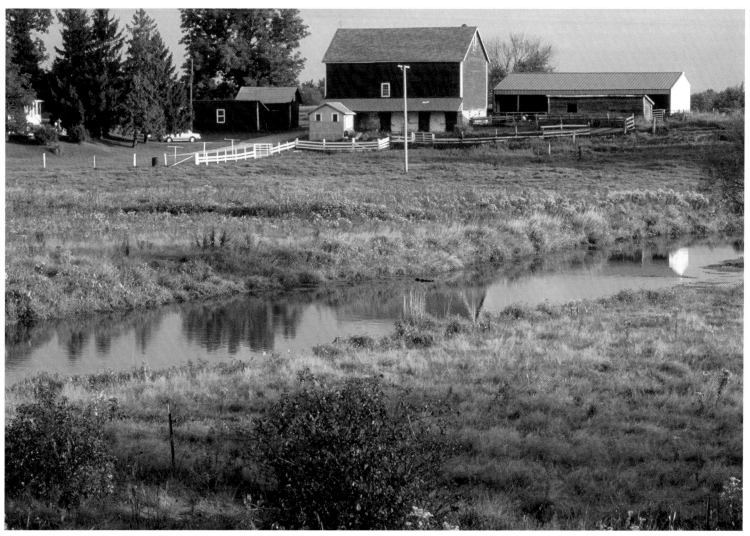

The same farm along Rustic Road 27, Summer, Green County.

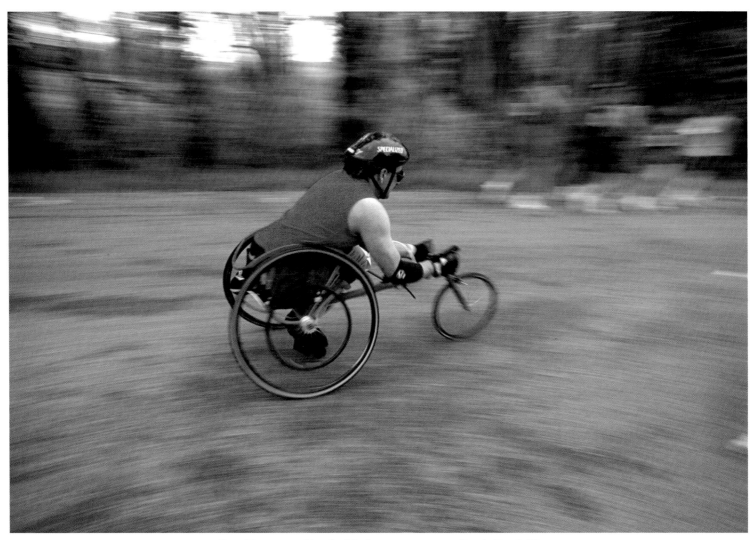

*Don Birzer races his wheelchair past runners on Rustic Road 19
during the Syttende Mai race, Dane County.*

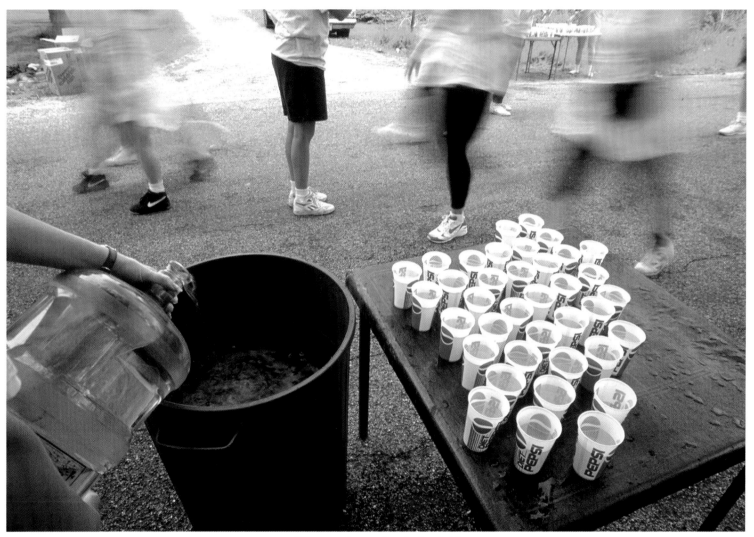

Water station on Rustic Road 19
during the Syttende Mai race, Dane County.

Cornfield, Rustic Road 2, Racine County.

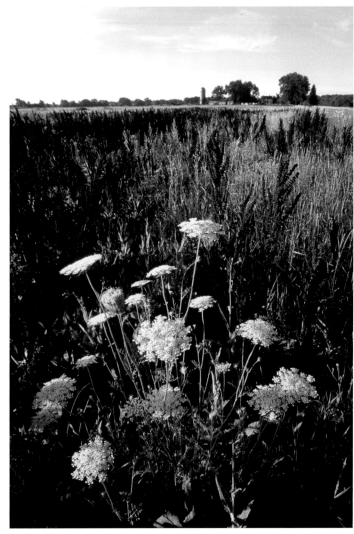

Queen Anne's Lace, Rustic Road 42, Racine County.

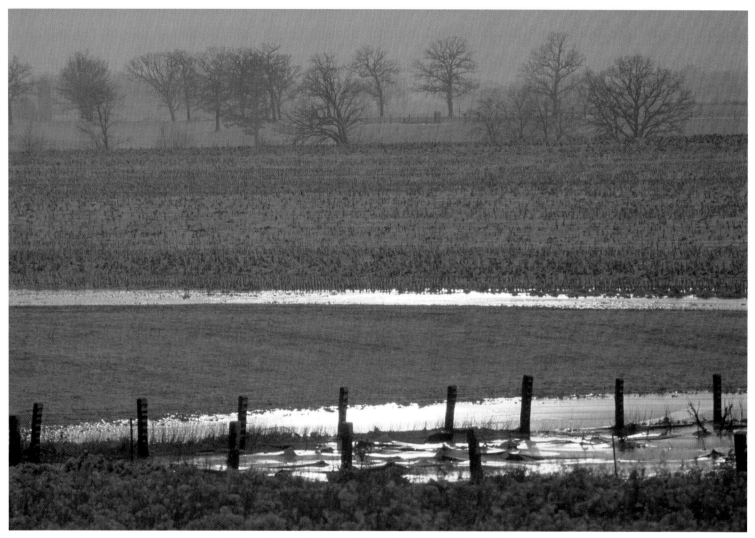

Field with standing water, Rustic Road 36, Walworth County.

The Rustic Roads of Wisconsin's West Coast

by Ben Logan

My love affair with little roads began because of my mother's father, D. M. Cranston. He was one of the few game wardens in the State of Wisconsin when I first remember him, a stern-faced man who could spear you with his eyes. He was awesome to me, a hunter of men, those who broke the laws. In those days the hunted men shot back at the hunter. Once Grandfather was captured at gunpoint, tied to a tree and left in the woods to die.

Those are stories I associate with the man. The man himself I came to know while spending a summer with my grandparents when I was thirteen. D. M. Cranston was then superintendent of the Wisconsin portion of Interstate Park at St. Croix Falls. In the park he was

Spring and winter views of Rustic Road 56 from the Bethany Lutheran Church, Vernon County.

23

uniformed and official, the stern Grandfather I remembered. Away from the park, almost always on some obscure road far from the crowds and pavement, a hidden version of the man appeared. He could not resist a road he had not yet traveled.

Grandfather drove a Model A Ford. The relationship between man and car was uneasy. He always set the emergency brake. He almost always forgot to release it. When he pushed down the accelerator and let the clutch fly out, the poor car would would seem to leap straight up. Out on the open road the engine roar would often stop all the talk. I would point, reminding him he had again forgotten to shift out of low or second gear. He would glare at me and grind the gears into high.

On some gravel or dirt road, Grandfather would yell

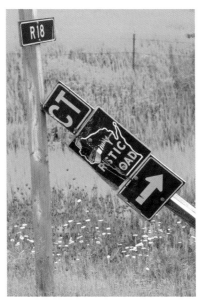

Damaged sign, Rustic Road 18, Barron County.

"Hey!" and slam on the brakes, throwing me up against the dash. More grinding of gears and suddenly he was backing up at full speed, looking to the right or left but never to the rear. "I wonder where that road goes," he would say and swing the car into an opening between the trees, onto a road even smaller than the road we were on.

He drove slowly, looking from side to side, sometimes stopping while we sat and watched the white flags of deer disappearing or a porcupine waddling across the road. Often he got out to identify a wildflower or vine or bush. Then, standing beside the road, he talked of wolves, lynx, bobcats or wolverines in such detail that I find it hard to believe we did not see those creatures, too, along the road.

In late afternoon, Grandfather liked to swerve onto

some little road that took us to the west. He would have me hanging out of the window, looking up into the trees for a smoke-like haze of yellow-gold that would be honey bees flying around an opening in a bee tree. He never cut the trees to harvest the honey. He just liked to find them.

I came to believe, that summer, that every little road leads to even littler roads and that destinations are not very important. Grandfather was really saying, "I wonder what we might find along that road."

We found a great deal, though rarely people. He had his fill of people in the park. This was a different journey, one that made Grandfather into a different man. And there we have a primary key for our journeys along Wisconsin's Rustic Roads.

The Rustic Roads assigned to me are cradled in a narrow band that wonders north and south, never far from the "West Coast of Wisconsin," the Mississippi River, which has always seemed to me to cut our nation into halves, the older East and the beckoning West with its lingering promise of "The Frontier."

In the Driftless Area, the unglaciated hill country of southwestern Wisconsin, the crooked Kickapoo elbows its way to the sand-barred Wisconsin, which flows to the mighty Mississippi. In the glacier-flattened, boulder-strewn land reaching toward Superior, the St. Croix River tumbles out of the north, forming a border with Minnesota.

I carry that image of rivers with me to each Rustic Road. Rivers and roads have an aura of destiny, of diverse people traveling, searching for something beyond what they know, as though trying to return to a familiar place they have never found.

I traveled my Rustic Roads from south to north, seeking them one by one in a single zigzagging journey. Perhaps that gives me an impression of unity that cannot easily be duplicated by a more one-at-a-time approach.

No matter. Each road has its own story to tell. Of course the road itself is not the starting point. You are. Rustic Roads are for those willing to transform themselves.

Speed is a dominating motif of our lives. Fingers on a map seek the shortest

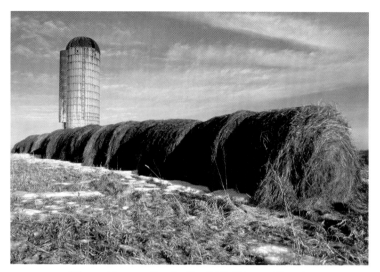
Silo and hay on Rustic Road 56, Vernon County.

piece of time between two places. A main highway is growling engines and howling tires, a tunnel leading to a destination. And a mind fixed too long on destination loses its peripheral vision, arriving somewhere with nothing stored from where it has been.

Rustic Roads promise something else–the joy of the journey. Once they lure us to them, they have power over us. At first, the habit of speed still with us, we drive slowly only because these are narrow, crooked, up-and-down roads. Soon, if we are lucky, we find ourselves driving slowly even where we could drive much faster.

That begins to happen when you join the world you are traveling through, turning on your ability to see, hear, smell, touch. The experience becomes richer still when you let what your senses are telling you find response in your feelings. Then you are a participant in the journey.

Each Rustic Road takes us to a miniature universe. There are awesome panoramas, yes, but more important are the story-telling details. The magnificent purple-blue of a clump of New England asters. Wind moving in

rhythmic waves across a field of grain. A little hilltop that says stop, come sprawl on your back here and find pictures in the clouds or just look up and look at all the different shades of blue. The careful, soil-saving contours of corn and alfalfa. A single red leaf suspended in the air. Here you can stop and watch it whirl, spiral, tumble, swoop from side to side, colors changing as it reverses from top to bottom, always reminding me of naturalist Hal Borland, who told us if we pick up one scarlet leaf we can hold autumn in our hand.

People grow larger along these roads. You, the traveler, grow larger. A man and woman standing in a farmyard are not just "farm people." They are unique individuals who reach out to your awakening curiosity and some creative impulse wants to give them a life story.

An old barn, adjusting itself to the terrain, is not just planes and roof slopes or a silhouette against the sky. It speaks of time, of those who built it, of successive genera-tions of people, even of successive generations of cattle and horses and yes, of barn cats, that have had a home here.

Houses, some abandoned and sinking gracefully into the ground, some twisted and resisting death–some occupied and revealing that houses, like families, are alive–tell their own story. Add-ons upon add-ons speak of families growing. Then it is an easy stretch of the imagina-tion to think of each new child learning the secrets of the child-hiding green of the land, or of teenagers wandering moonlit fields, wondering who they are and where the future is.

I can only give you such glimpses of what reached out to me along these roads. I cannot say what you will find. Travelers must make each one their own.

My first road, Rustic Road 56 near Ontario, is stored most firmly in my mind because it taught me how to behave on a Rustic Road. I came from the north, the steep climb leading me to misty views of the Kickapoo

Valley. Nearby were sleeping reminders of earlier days, a lone-standing silo, a falling tobacco shed, a windmill decapitated by the wind, a cluster of lilacs that told me where a house must have been.

Then, a working farm with a fine round barn. John Fish and his stepson, Wayne, rebuilt the barn, an act of love for a building dating back to 1910.

There are old log buildings along the road. One, a house carefully restored, has a wing dated 1855, the other wing 1880, telling me these people care about the past. No one answered my knock. Through the window I could see a wood burning range and home-canned vegetables in old glass jars. That, too, helped me know these strangers.

I passed a farm with a working windmill, a rarity now, and realized I could see no electric wires anywhere. Almost surely it is Amish people who live there.

Crossroad signs were a lesson in early history– Norwegian Valley, Irish Ridge, Dutch Hollow, Indian Creek.

Standing atop Sand Hill is Bethany Lutheran Church, built in 1912. Earlier congregations met in farm houses and the schoolhouse. The old registry and hymn books are in Norwegian. Four women, cleaning the church for a funeral, made sure I learned the date of their fundraising lutefisk dinner. They laughed when I told them my Norwegian father said lutefisk was "squishy."

The road took me past the old Sand Hill Schoolhouse, which is now Sand Hill Town Hall, and that told me a story of change. The little rural schools were once our community centers.

Rustic Road 55, near LaFarge, winds through the woods along the Kickapoo River. It is all isolation and quiet. A tiny, tall house, that might have been cut out of gingerbread, had a sign saying "Little House on the Kickapoo." I did not meet the people who live there, but

I came to believe, that summer, that every little road leads to even littler roads and that destinations are not very important.

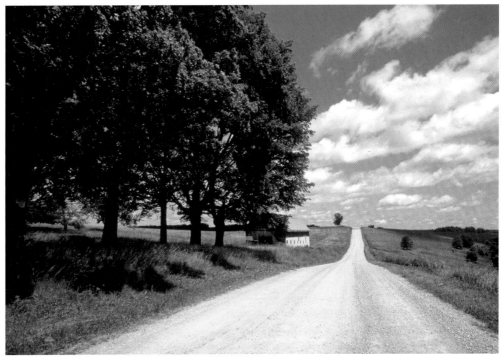

Rustic Road 56, Vernon County.

the sign tells me something of who they are.

South of LaCrosse, is a top-of-the-world road, Rustic Road 26, that surprises with its glimpses of the Mississippi River and Mormon Coulee Creek Valley. Lower down is an old mill, a solid stone building that looks as if it will stand there by the stream forever. It is easy to imagine a creaking waterwheel and horse- and oxen-drawn wagons waiting in line with wheat to be ground into flour. Not far

Leonard Street, West Salem,
Rustic Road 31, LaCrosse County.

away, a root cellar was long ago hewn into the stone. Near it lives a woman who is proud of that cellar and was pleased to show it to me.

Rustic Road 31 stays sedately on the paved streets of West Salem, original home of an important early Wisconsin writer, Hamlin Garland. Is that road rustic? Is it rural? Well, I look for mind-stretchers and reminded myself that most little Wisconsin towns served the farms and have their own rural past.

Rustic Road 64 is a pleasant loop that rescued me from the impatient drivers on Highway 53 north of Holman. Surely one of this road's purposes is to give access to the Van Loon Wildlife Area, but I could find no sign telling me how to get to the hiking trail.

Near Maiden Rock, Rustic Road 51 startled me with its feel of isolation and the past even though it is close to the Great River Road. The rock that gives the town its name rises sheer above the river. An Indian maiden,

being forced to marry a man she did not love, is said to have leaped to her death from the high bluff. Whether it is history or a romantic legend does not seem to matter. The story lives. Nearby, a new "old log cabin" celebrates Laura Ingalls Wilder, who told the story of her childhood here in her book, *Little House in the Big Woods.*

Rustic Road 13 seems as unlucky as its number. It is a disturbing oddity. The pleasant wooded road is being engulfed by the new houses of a bedroom community for the Twin Cities, a symbol of how urban areas sprawl relentlessly outward, even across state lines. When I talk to some of Hudson's old-timers I find a regret that is close to anger for what has happened to a once-upon-a-time "little town" that is being eaten by change.

Rustic Roads 3 and 4, near Glenwood City, were all imagery and feeling, the peaceful rolling land saying all's right with the world. The scent of frost-dried goldenrod was strong in the air. Wind was winnowing bright fallen leaves along the road. An intersection sign told me to turn both right and left. I turned right and then came back. Because of that, I saw a beaver gnawing on an aspen tree. Detours and getting lost often mean adventure, proving that life is quite accidental anyway.

To find Rustic Road 15, I simply turned off the main highway where dozens of sandhill cranes were feeding in a field. The road goes west, determined to take me again to the river country. At a curve to the south I found Benson Creek Trail in Governor Knowles State Forest. Tangled timber along the trail reveals the power of a major storm. Glimpses of water through the trees mark the St. Croix River. Two young men paused at the trail head with their mountain bikes, ready to ride the 22 miles of the trail and then ride back, despite the promise of rain. I gave them each an apple from the Kickapoo country. Their talk of the trail, the woods and the river said they know well the joy of wilderness and things rustic.

That was my last road, and I was filled with a sense of the rich diversity of my journey. Suddenly I was thinking of Aldo Leopold, the ecological prophet whose life and being were such gifts to us. Passages from his book *A Sand County Almanac* are precious companions for any journey that takes one, as Rustic Roads do, across the Wisconsin land. By land, Leopold said, is meant all things on, over and in the earth. Just as we have tended to see a road simply as something that takes us where we want to go, Leopold believed we have seen land as a commodity which we own rather than what it is–a community to which we belong.

On my way back from the north I picked up a brochure which described Minnesota's Mall of America as "The Ultimate Destination." I didn't know if I should laugh at the arrogance or cry for the folly of it.

Still, it raises this question: where did my journey along the West Coast of Wisconsin take me? Surely not just home again–home to the land and house where I was born. I began all this by telling myself to avoid thoughts of destination and just celebrate the journey. Now, that is not quite good enough. In becoming a responding participant to where I have been, I have learned things about myself and the people and the land of Wisconsin. That has made me, subtly, a different person.

On these Rustic Roads, our destination is ourselves.

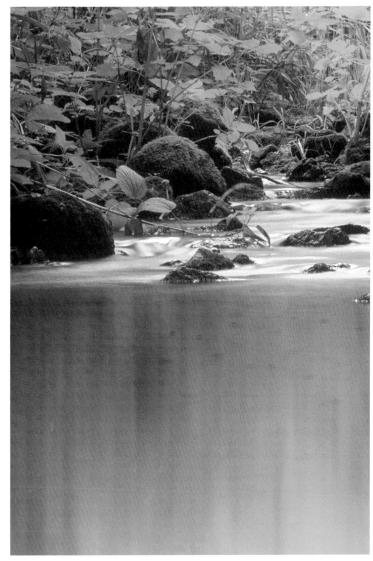

Trout stream, Rustic Road 51, Pierce County.

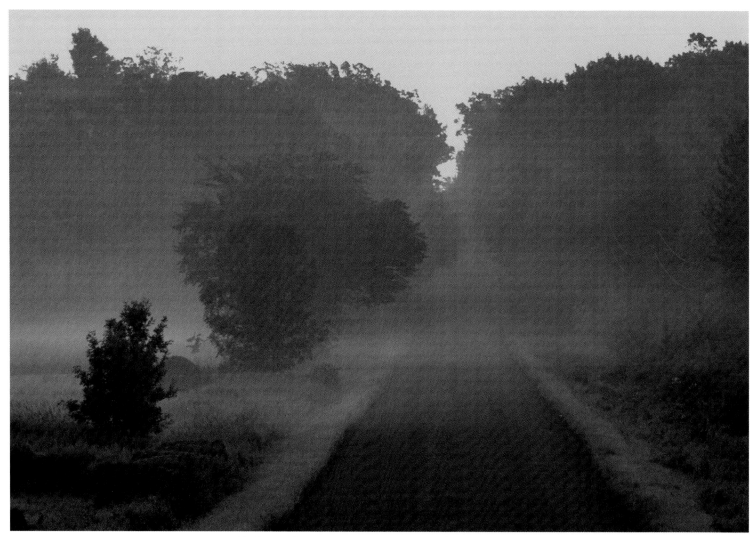

Early morning mist across Rustic Road 28, Polk County.

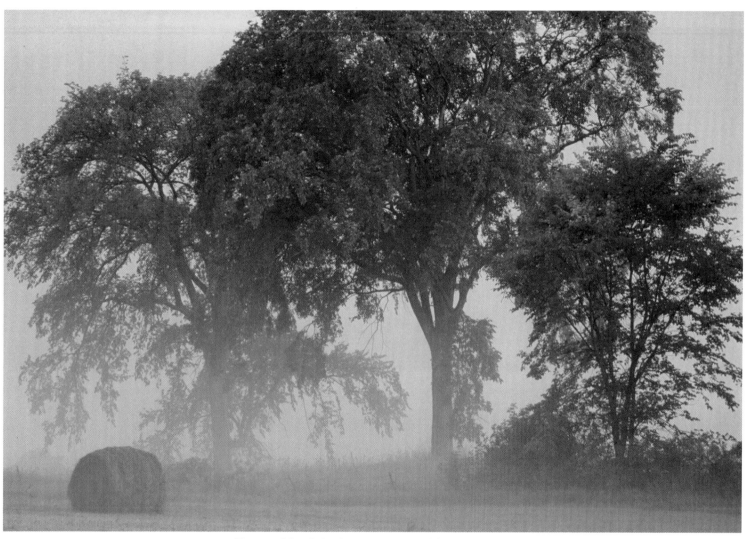

Trees and hay bale along Rustic Road 28, Polk County.

Rustic Road 51, Pierce County.

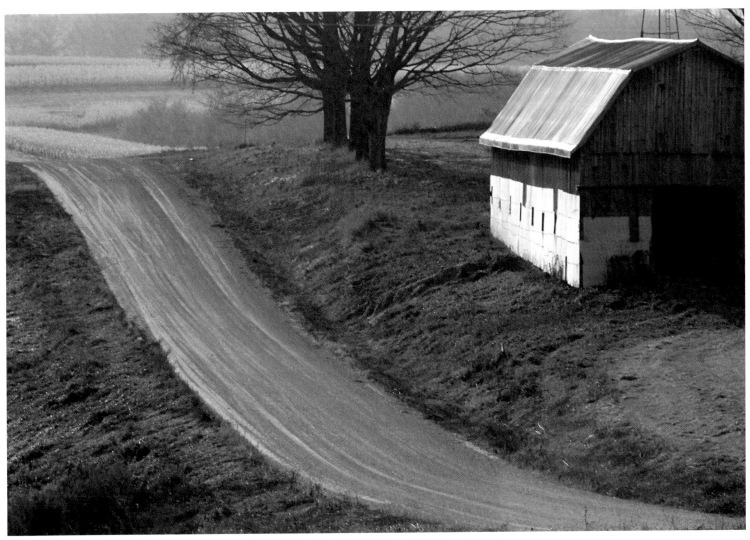

Lower Ridge Road, Rustic Road 56, Vernon County.

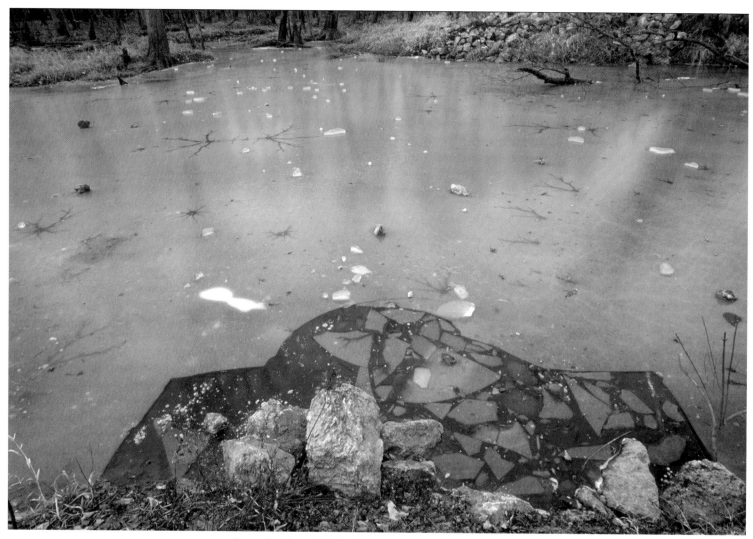

Ice and rocks on the Black River, Van Loon Wildlife Area,
Rustic Road 64, LaCrosse County.

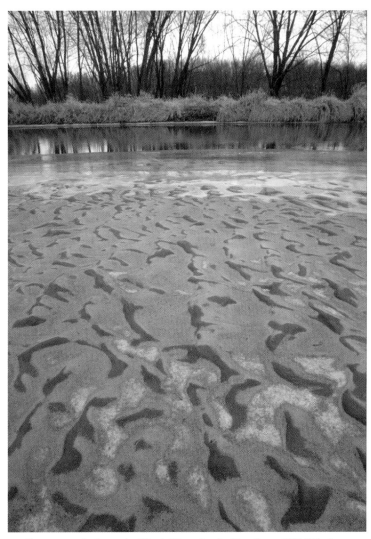

Frozen sand along the Black River in the Van Loon Wildlife Area.
Located along 7 Bridges Road, it is accessible by foot from
Rustic Road 64, LaCrosse County.

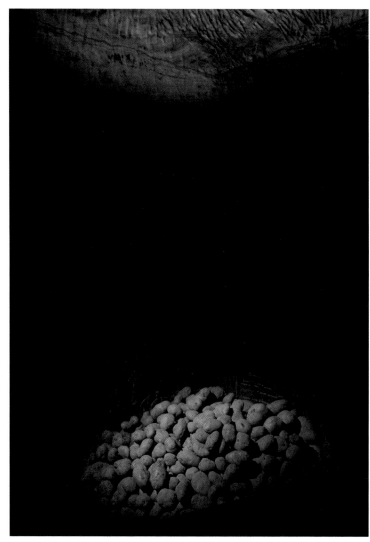

Potatoes stored in a root cellar carved out of a hillside in 1876,
along Rustic Road 26, LaCrosse County.
The marks on the wall are from the pickax that was used to dig it.

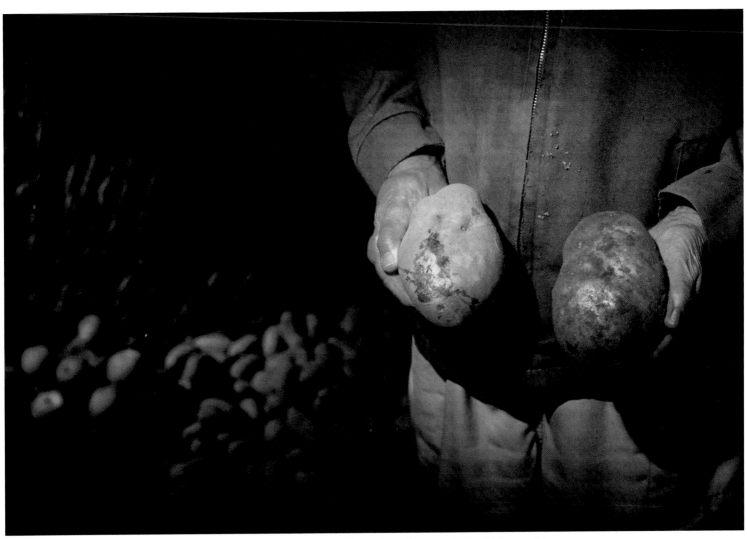

Lillian Jahnel with some of the produce she stores in her 118-year-old
root cellar on Rustic Road 26, LaCrosse County.

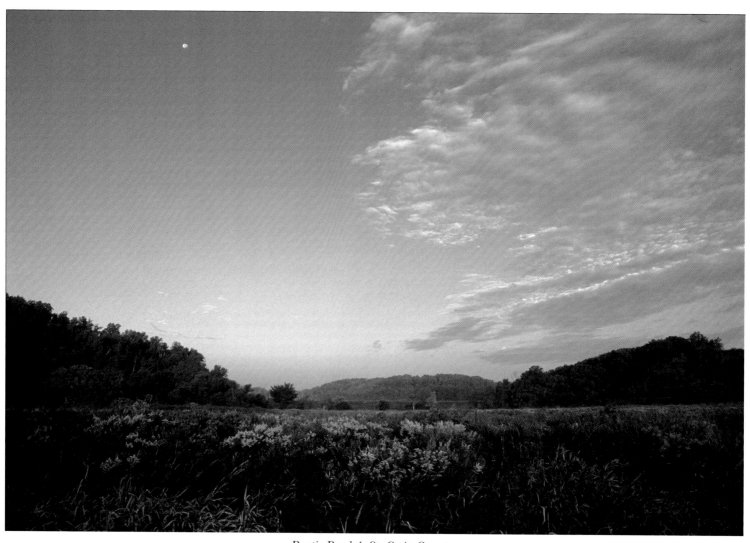

Rustic Road 4, St. Croix County.

The Old North Country Roads

by George Vukelich

Nowadays, they call many of the little sand and gravel roads up in Vilas and Oneida counties "Rustic Roads." City folks are coming up to drive these roads because they've heard "something" is here. Some of the folks aren't exactly sure, though, what it is they're supposed to see and feel.

Some folks report seeing trees and stumps, and then more trees and more stumps. After all that, the folks confide, they went shopping in Minocqua. Or Eagle River. Or Manitowish Waters.

For me these Rustic Roads, these beloved back roads and byways off the main highways, are pathways to, as singer Glen Yarborough so eloquently phrases it, "the Old

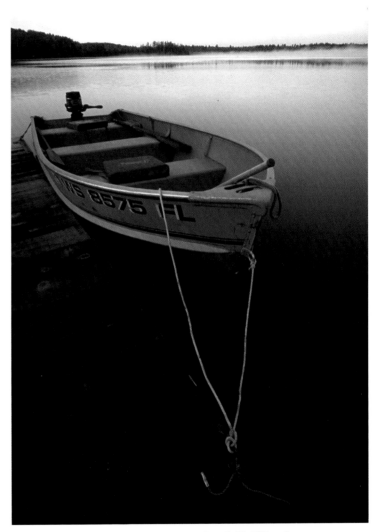

Jim Errington's boat. Rustic Road 60, Vilas County.

Wisconsin that we knew."

Did you know this north county in the pine-winey summer days before chainsaws, when you could get intoxicated on the smell of hemlock in the sun-warmed air?

Did you know this north country in the winter before snowmobiles, when the only tracks in the snow were made by the Four-Footed Ones looking for food and the Two-Footed Ones looking for the outhouse?

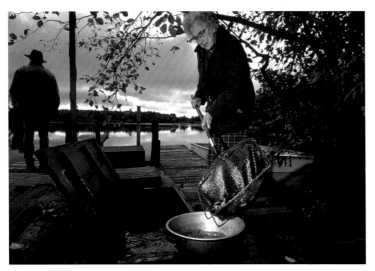

Edith Fredrickson scoops out minnows at the minnow stand owned by Edith and her sister, Hazel. Rustic Road 60 at Star Lake.

Did you know this north country before there were all-terrain vehicles and dune buggies? Before jet planes in the sky and jet-skis in the water? Before gasoline-powered cars, trucks, motor homes, motorcycles, motor scooters, and motorized ice augers?

Did you know this north country, this Old Wisconsin, without noise? Did you know it when it was as silent as church, and the only sound for miles around came from little chickadees swinging on the pine branches like tiny tinkling bells?

If you did, you are blessed.

If you didn't, you are about to be blessed, for when you travel the Rustic Roads, you will travel through a seam in time, a pathway to yesterday, a byway to the Old Wisconsin where the past is present and, hopefully, where the present is the future—where new chickadees perch on the ruins of the old log cabins.

In that silence, there are shifting shapes back in the

trees, sunlight, and shadows. Some are deer and some are not. North country Rustic Roads are peopled with ghosts.

A lifetime ago, through these very trees, the Old Man trailed his wooden guide boats behind his beat-up fish car to the nameless bass lakes hidden back in the boonies, where no man had gone before—including game wardens.

After he had his heart attack and Doc Colson told him to cut out the deer hunting, the Old Man and my mother drove the gravel and sand roads that ran right over the Michigan border, watching for partridge on the road shoulders and back into the trees, their cased shotguns on the back seat, hot coffee in their hands, and the Wisconsin football game on the car radio.

In those days, you saw a lot of old tarpaper shacks in the bush where Old Coots, honed as bone-hard as hickory axe handles, lived out their lives alone with their kerosene stoves and outside plumbing, living off the cutover land like packrats, living off the deer they shot in the fat years

and the rabbits and squirrels they shot in the lean. They were all hunters who could sit still a long time, and they could all shoot straight.

The Old Coots were loners, truly at home in the bush. They were free as ravens and as hard-bitten as those scavenger birds, surviving in the slashings of the great logging frenzy that had swept through the Big Woods like a war.

I see some of the Old Coots every time I drive these lonesome roads. When I pull off onto the crunching gravel

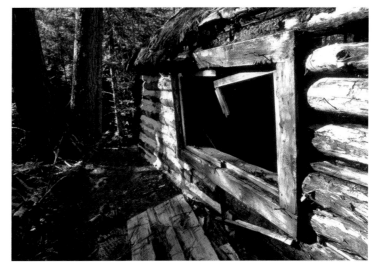

Deserted log cabin on Rustic Road 59,
built by a Minocqua pioneer homesteader.

shoulder, turn off the engine, and roll down the window, I even hear them. They cackle like ravens.

You can see deserted log cabins along the Rustic Roads in the north country. There's a memorable one over in Oneida County on R-59, one of my two favorite Rustic Roads in all of the north country.

My other favorite is R-60 in Vilas County, long known to locals as County K, which winds through the 220,000-acre Northern Highland American Legion Forest between County M and County K. Paved now, this gem of a "blue highway" is still the classic, old-timey north country road. It winds unstressed through coniferous and hardwood forests, past lakes that knew my father's wooden boats and his wooden Pikie Minnows, Bass-Orenos, and River Runts.

This road also boasts working relics from my father's time: the ancient Frederickson's Minnow Stand on a weed-filled corner of Star Lake; and further down, the old Errington's Cottages & Motel ("Open Year Round") with your hosts Lois and Jim Errington.

"If you fish," Jim says, "we're a fish camp. If you hunt, we're a hunters' camp. If you swim, we have no beach."

Back on R-59, you must pause at the log cabin that was built by a proud Minocqua pioneer who is now as desiccated as his lifeless north country house. The cabin squats on a high bank above the unpaved road like some forest animal, mortally wounded, waiting for the end. Its back is broken, cracked open by the long north country winters; its roof is collapsed and crushed like the dreams the long gone occupants must have had in that quiet, innocent time.

You must park your car in a place like this and go on foot. You must go in awe and humility, as you would go to any sacred shrine hushed in the shafts of ancient sunlight streaming through ancient cathedral pines. You must go on foot to see and feel for yourself what was once here and what, in a very real sense, is here yet. When you come

*I*t winds unstressed through coniferous and hardwood forests, past lakes that knew my father's wooden boats and his wooden Pikie Minnows, Bass-Orenos, and River Runts.

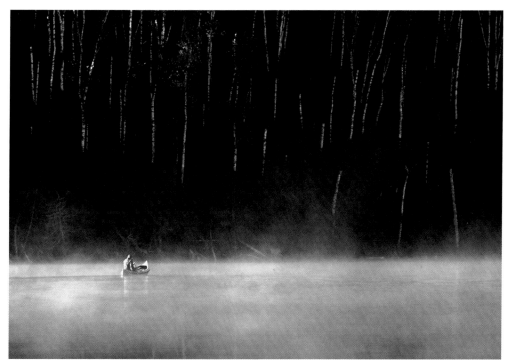

Canoeist on Little Star Lake, Rustic Road 60, Vilas County.

in that spirit, you will be changed, even if you come from the cities—perhaps especially if you come from the cities.

Yes, the north country is peopled by ghosts. Away from the Red Owl stores, the neon signs, the TV antennas poking up through the pines, and the crowded, whizzing Highways 70 and 45 and 32, you will see them. There is something in the mists, materializing in the trees, on the tote roads, and on the pothole lakes—if only you look, if only you listen. You can still see deserted hardscrabble farms along here, too. The fields are sown with stones, and when you park the car in the old barnyard, you will hear the wind rattling through the windowframes, and sometimes you will see a rag of a curtain stirring like a living thing.

Once, in the mist of a gray fall morning, a particular deserted farmhouse stuck in my mind. The empty windows above the empty door seemed, of a sudden, to be a face—comical, uncomplicated, and yet frightening in the way that certain carved pumpkins can be comical and yet profoundly disturbing. Perhaps vacant eyes—not only in people, but in buildings, too—account for this sense of disquiet and uneasiness. Abandoned house. Abandoned farm. Abandoned. The very word touches our core.

That morning I was on a story for *Wisconsin Trails* magazine. I was traveling these same backcountry roads, but they weren't called "rustic" then, and I forget what the assignment was. People? Fish? Eagles? Certainly not Rustic Roads.

Somehow that eyeless north country farmhouse was waiting for me, and it pulled me into the barnyard. We stared at each other, that house and I. I walked around the outside of the house, around and around, and then I went inside and looked—and listened.

Man walks his minute, and then no more.

The farm couple saw this kind of morn

in another year—a dead, lost month.

The house so new it smelled of wood.

His bride a warm and wondrous joy.

Did they love their land?

Did they love their life?

The strong, young farmer

and his strong, young wife?

Was his a windburned, kindly face?

Was this a quiet, happy place?

Did they have children,

and were some boys?

Did they keep Christmas

with homemade toys?

No one knows, no one can say

except the one truth here plain as day.

No one owns this land at all.

This is the lesson of the fall.

The land owns us,

not the other way round.

We are walking on eternal ground.

The squirrel stores nuts

in the rotting floor.

Man walks his moment,

and then

no more.

There are no hard and fast rules for traveling the Rustic Roads, in the north country or in any other part of Wisconsin.

There are, however, two slow and easy rules.

First, remember that not all of Wisconsin's truly beautiful back roads and byways are included in the official Rustic Roads guidebook that's published by the

Department of Transportation. You can find your own. They're all over the map. As a matter of fact, a lot of them aren't even on the map. In a way, it's like finding some of the best fishing spots—those potholes back in the middle of nowhere. Get off the highway, roll down the windows, and slow down. When you can't see wires, when you start hearing birds, you're close.

Second, when you drive a Rustic Road—the Department of Transportation's or your own—park the car somewhere for a spell and walk a little bit. In any season. Leafy trees are good, but barren trees aren't bad either. Watch. You are traveling in a time tunnel to The Past. Watch! And listen! Listen hard!

You will hear—perhaps for the very first time—the Old Wisconsin that we knew. The eternal mysteries dwell yet along these roads, and above them the ravens still fly—on guard, patrolling, watching for you.

Come! You still have time. But come! 🍐

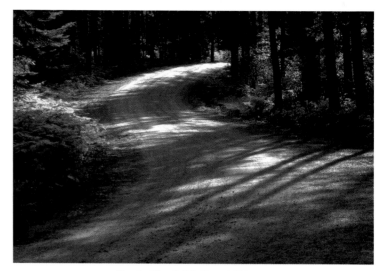

Rustic Road 34, Forest County.

George Vukelich
Writer, Humorist, Friend and Defender of Mother Nature
Traveller of Many Roads Less Travelled
July 5, 1927 – July 4, 1995
🍐

George, we wish you'd lived to see the publication
of your tribute to Wisconsin's Rustic Roads.
You'll be with us in spirit as we wend our
way down the roads you loved so well.

Pothole filled with water on Rustic Road 59, Oneida County.

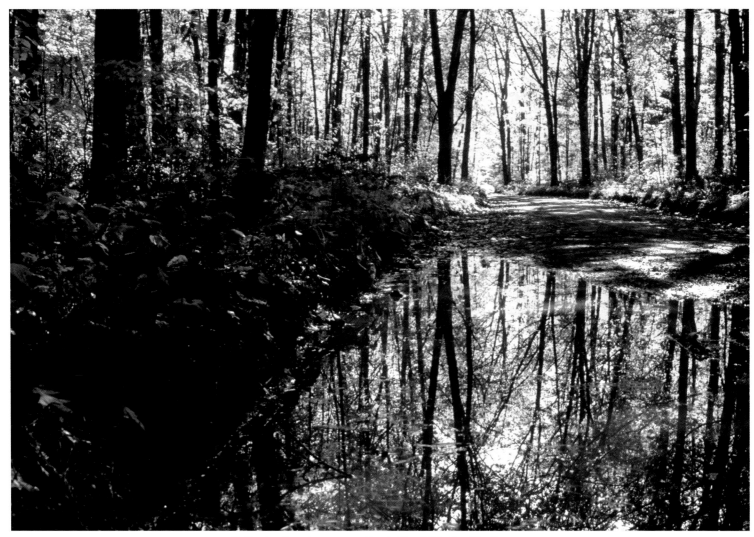

Reflection in rainwater on Rustic Road 59, Oneida County.

Private swimming hole. Rustic Road 44, Marinette County.

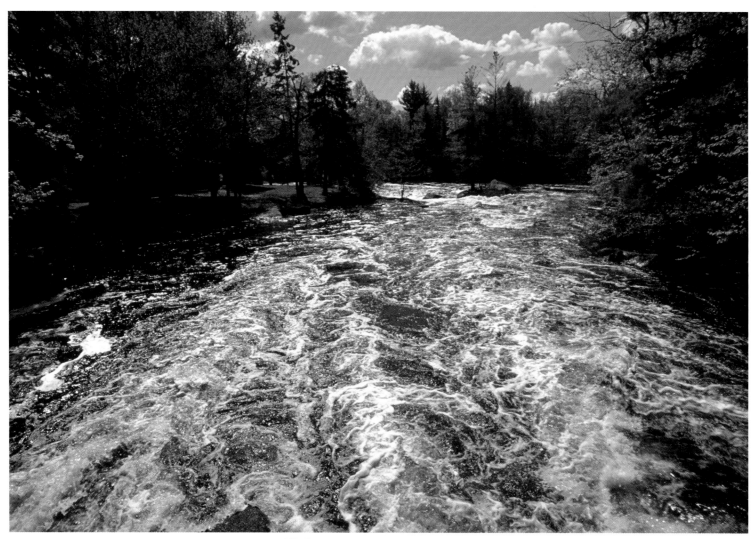

The Peshtigo River at Goodman Park.
North end of Rustic Road 32, Marinette County.

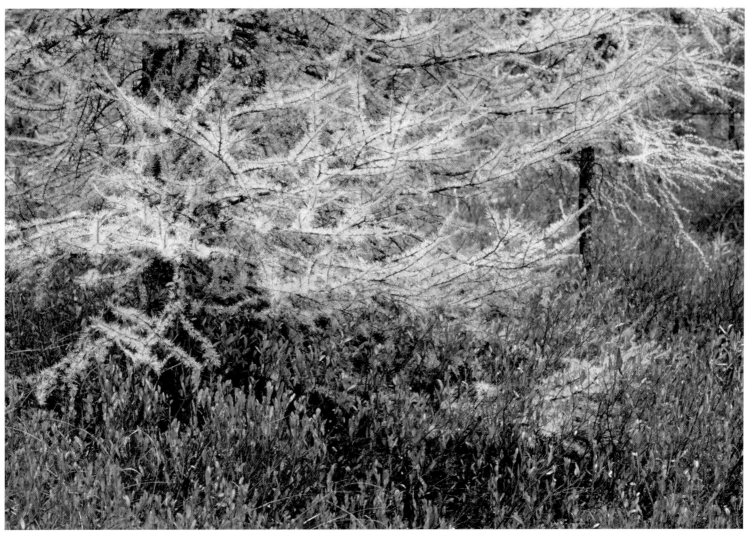

Tamarack tree and bog. Rustic Road 1, Taylor County.

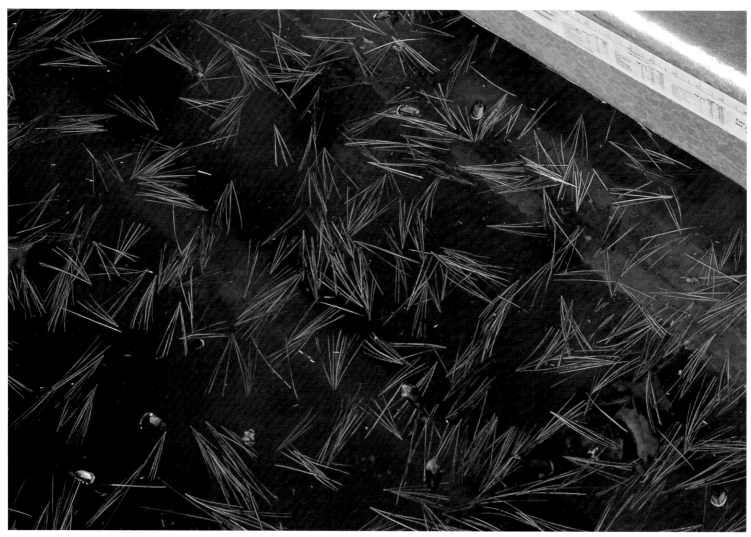

Pine needles in flooded fishing boat.
Rustic Road 60, Vilas County.

Birch branches in the forest along Rustic Road 60, Vilas County.

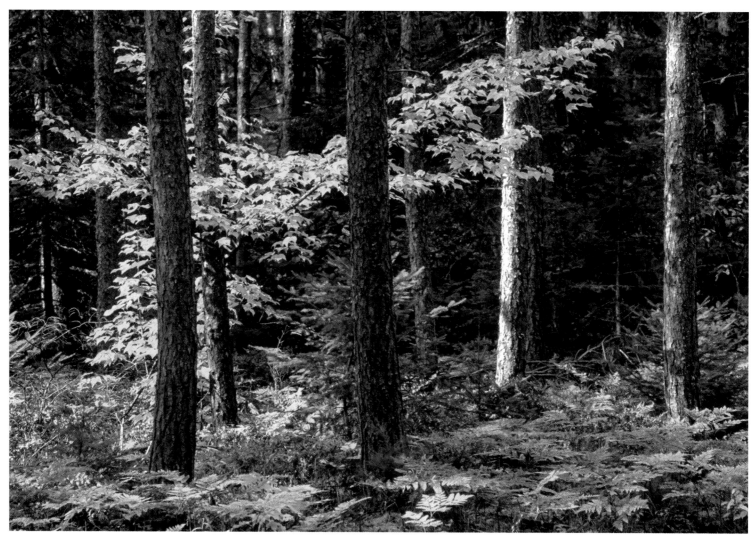

Woods along Rustic Road 34, Forest County.

Forest clearing after the first hard frost.
Rustic Road 60, Vilas County.

Wildflowers along Rustic Road 34, Forest County.

Rustic Road 12, Adams County.

The Old Marsh Road

by Jean Feraca

It is quiet in the wild heart of Wisconsin. The wind rises and falls in the aspens and pines of the Great Marsh, a ceaseless soughing. It is so quiet you can sometimes hear a leaf fall.

People who live here say it is like an empty canvas, clean and white. Sounds enter one at a time, laid down like paint. A shotgun report. The slamming of trains three miles away. A low moan in the middle of the night. The bugling of cranes in early spring. They enter, punctuate, and clean the mind.

Most of us are awash in sound and yet hear nothing. My friend, who has lived on the marsh for over 20 years, can hear the faint rattle of ice crystals hurtling over the

frozen surface of the snow when the silence is at its most profound. I myself have spent whole days alone in his house, attuned to the sibilants of his fire and the tin pan plunk of raindrops from his roof.

Bogs are lonely places. They attract misanthropes. My friend came here like so many other city refugees, disgusted by Chicago. He bought the only land he could afford: 80 acres of marshland in the middle of Wisconsin. He brought nothing with him but an axe, a wheelbarrow, and a dog named Charlemagne—"Charley" for short. Charley drove off the building inspector. For two years, my friend spoke to no one. He was an angry young man with a jackpine log on his shoulder and a penchant for

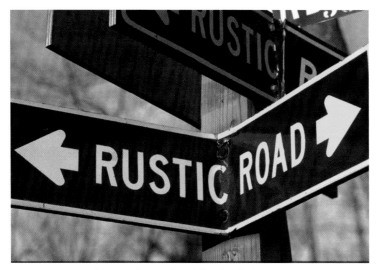
Sign on Rustic Road 21, Sauk County.

attacking chainsaws. Anger felled the jackpines and pitched the roof. Anger dug the pond. Anger cleared the road. And all the while, the marsh was claiming him, folding him into her rich mix.

He walks out on the marsh. I follow close behind. He wants to show me a tamarack standing a short distance from the road.

It has taken us the better part of Sunday morning to get here, following the map to Cottonville Avenue, Rustic Road #50, a dirt road in the middle of Adams County. We have been driving across the bottom of what was once an immense glacial lake—old Lake Wisconsin, its shoreline still visible on the rim of the eastern horizon. The aspens

and birch trees have all turned gold; the road is lined with smoldering oaks; there is a fire in the maples. But all of it this fine October morning is muted by a mist that cools the commotion. A hawk floats over the field. Flocks of wild turkeys pass in front of us, so smug they hardly bother to pick up speed as they scuttle into the underbrush. "This is paradise," my friend says as we turn onto Czech Road. "Edge country, in environmental terms. This

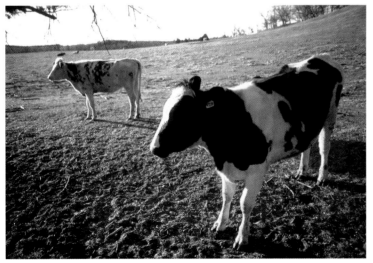

Cows along Rustic Road 24, Waupaca County.

is where the prairie of the south meets the northwoods."

The sense of the old lake intensifies as we round a bend and out of the mist Roche-a-Cri Mound suddenly hoves into view—a glacial remnant and one of the highest peaks in the state, looking for all the world like the prow of some great fossil ship plunging toward us through a copper surf. She is sailing straight out of time, this Rock-of-Tears, and as we speed away, we see that she wears the remnant of a rainbow where the sun is trying to break through—a rock halo. It seems a kind of miracle.

But such spectacles are not typical of this place, nor of the people who stubbornly cling to it like my friend. Paradise on earth is never without its paradoxes. The marsh may well be one of the most productive ecosystems in the world, but "the richest real estate in North America," as my friend is so fond of calling it, is more commonly known as the hole in the Dairy Belt, the last place settled in Wisconsin and the poorest to this day.

The Sand Counties are speckled with abandoned farms. Aldo Leopold reclaimed one of them and developed an enduring land ethic in the process.

It takes tenacity to per-sist in a place shrouded with mosquitoes, blasted by arctic winds, and peri-odically buried in dust. You have to be knotty and resinous like a jackpine. And to find paradise in a place so forbidding, to prize what others despise, you have to be downright perverse. Who else would stake a claim in a flatlander's Appalachia, or dare to put down roots in a queasy bog that has swallowed up whole corduroy roads? People in love with solitude and deeply suspicious of the social contract.

Field of sand. Rustic Road 24, Waupaca County.

Leopold and his ilk. Swamp fathers like my friend.

"Look at that. Isn't that luscious?" he once asked me, scooping up a handful of black muck from the marsh. "That's peat," he said, beaming.

The quiet deepens as we head down Cottonville, the tires making very little noise as they churn through the soft dirt that ripples underneath our weight. "Deliciously unimproved," says my friend, "like so many roads in the county used to be. Two tracks with grass growing down the center. That was when a man could still have a sense of the impact he makes on earth."

Getting out of the car, we sink in the shoulder, thick

and buttery, soft as a body underfoot. Yes, a body, I think to myself. We are walking on the body of the earth.

There is always a sense of trespass, somehow, when setting out on a marsh. Theodore Roethke wrote about it in *Moss Gathering*. "Something always went out of me when I … plunged to my elbows in the spongy yellowish moss of the marshes," he wrote, summing up his sense of shame in disrupting the natural order. "And afterwards I always felt mean, jogging back over the old logging road/As if I had disturbed some rhythm, old and of vast importance/By pulling off flesh from the living planet."

The marsh has been raped so many times—stripped, gouged, drained, and burned—in the effort, inevitably futile, to make it serve. But nothing works. Its very uselessness protects it. There it squats in the middle of the best dairy land in the upper Midwest, a foul hag wrapped in a greasy shawl who chooses to reveal her glories to only a select few. And what do they amount to? What is the value of the undrained marsh, anyway? A handful of peat? Two black snakes mating in the grass? A meagre harvest of wild cranberries it take you three years to discover hidden under the moss? And this you call "sustainable"? The "unearned dividends" of life on a crane marsh?

We make our way around bumpy hillocks and matted clumps of wire grass to reach the tamarack, although it is only a short distance from the road. Criss-crossing and doubling our tracks, we have to be careful not to sink ankle-deep in the muck. The road across a marsh is never straight. Deer and muskrat know that. Indians did, too. "Anyone who comes must travel slowly and with thought."

The tamarack is still green in mid-October. Later on, it will turn a fiery gold and lose its needles in the swirling snow. An evergreen pretending to be deciduous, the tamarack more than any other tree belongs to the marsh. Even before the cranes came out of the Pleistocene, the tamarack was here. You can see hundreds of them growing

*D*eliciously unimproved," says my friend, "like so many roads in the county used to be … That was when a man could still have a sense of the impact he makes on the earth."

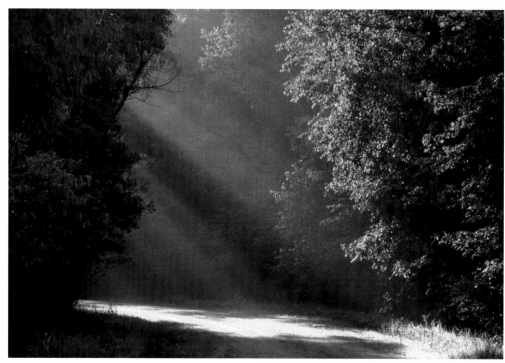

Cottonville Avenue, Rustic Road 50, Adams County

straight out of the marsh bottom from Roche-a-Cri Mound or Quincey's Bluff or Lone Rock, sending out roots wide and true instead of deep. My friend breaks off a sprig and hands it to me. "Here," he says. "A marsh bouquet." It is feathery and delicate, its needles exploding right out of the branch in starbursts, with tiny rosebud pinecones in between. I tuck it into my turkey feather fan and we walk on.

We find a path of wooden slats some hunter has laid down that leads across the crest of the grass to a stand hidden in some popples. The hunter is nowhere in sight. Halfway there, we turn and pause to look out.

"Look for me under your bootsoles," Walt Whitman said in *Leaves of Grass*, and I can almost find him in the democracy of these grasses. Backlit, their stems are glowing neon green and gold, their long wiry tips coiling and uncoiling, whipped to a froth by the marsh wind. It is a sea, this wavy pasture where the only horses that will ever run are the colts of cranes. And it sounds like the sea, an incessant threshing that carries other sounds: the patter of aspen leaves letting go their many-penny gold. "Quaking" they're called, and it's easy to see why, watching them spin on their stems in the light, creating a kind of strobe effect that's dazzling. And then there is a deeper, hoarser sound—the metallic rasping of the oak leaves.

It is all electric and singing, this body of light and air and grass and water that sways before us. We are walking on water. The very logs are soft as sponges and covered with electric-green mosses. Everything is breathing and making a loose weave of wind and water, the elements mixing freely and intermingling in their intercourse. Here is communion and community. No wonder Whitman called his great paean to democracy *Leaves of Grass*. Where do we find egalitarianism in original form if not here in the grasses of the marsh?

"I like its levelness," the Swamp Father once told me,

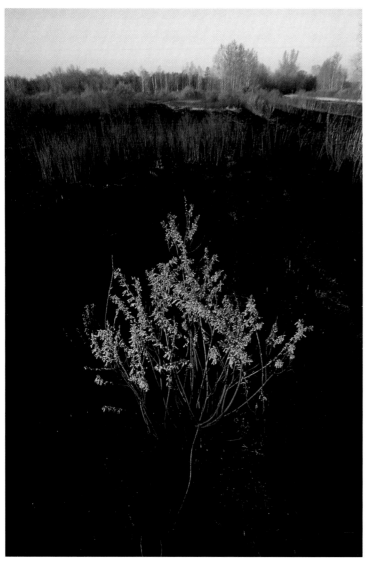

New growth after a burn, White River Wildlife Area.
Rustic Road 22, Green Lake County.

surveying his marsh from a thicket of scrub oak. "It teaches me not to judge people or things by appearances."

And what else has it taught him?

Tenderness. The desire to protect it.

"If a fool would only persist in his folly, he would grow wise." William Blake said that. Persist we did. But have we grown wise? The whole sorry history of the marsh says so much about the folly of human enterprise. It takes a man deeply pessimistic and suspicious to guard anything so bruised, tired, and misunderstood as the marsh. A misanthrope makes a good steward. But I am not so chary. I do not believe in my heart of hearts that man and nature are forever at odds, or that paradise can never be regained.

I am no nature girl. It is people I love. The Swamp Father has been a patient teacher, and my sense of connection to this place is through him. I see in him a kind of hope. He stands for us, not as we have been, but as we are

becoming. Like the crane, he stands out here on the pages of history, his own and ours—first as trespasser, then as homesteader, and now as steward. He is wildness. And he is civilization. He understands that in the great ethos of the marsh, economy and ecology are one and the same thing.

The same rule that governs a marsh governs a poem. He lives by that rule. Less is more. ♠

Grass along the marsh, Rustic Road 22, Green Lake County.

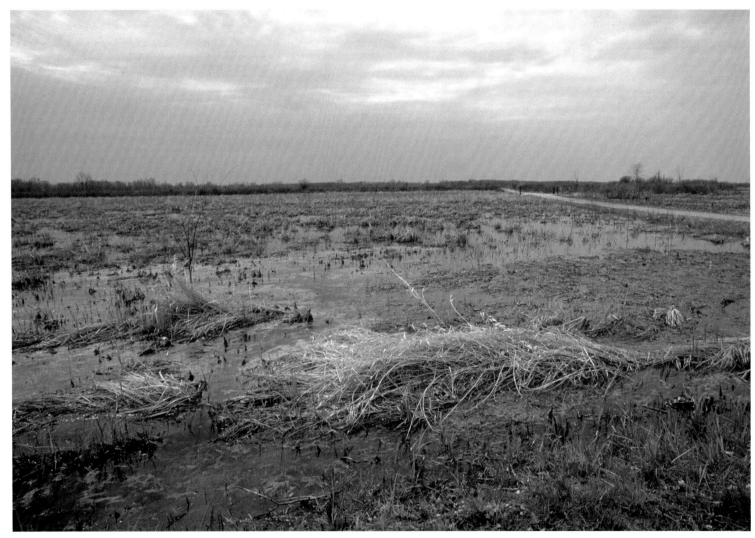

Spring, Rustic Road 22, Green Lake County.

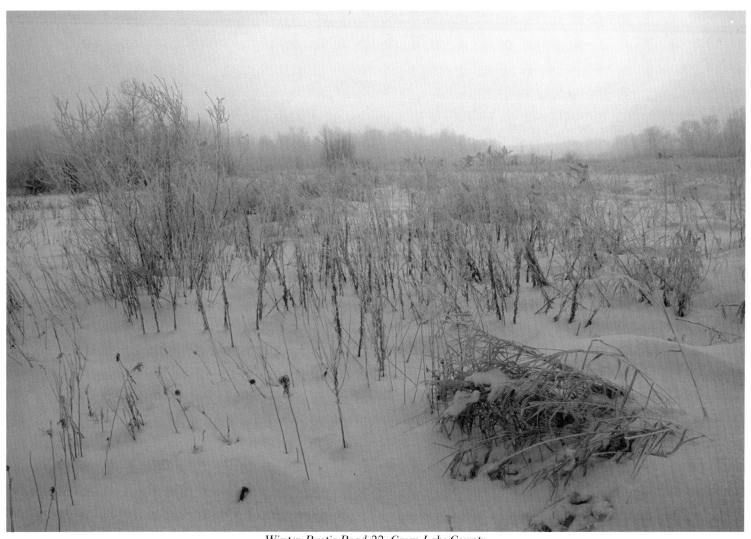

Winter. Rustic Road 22, Green Lake County.

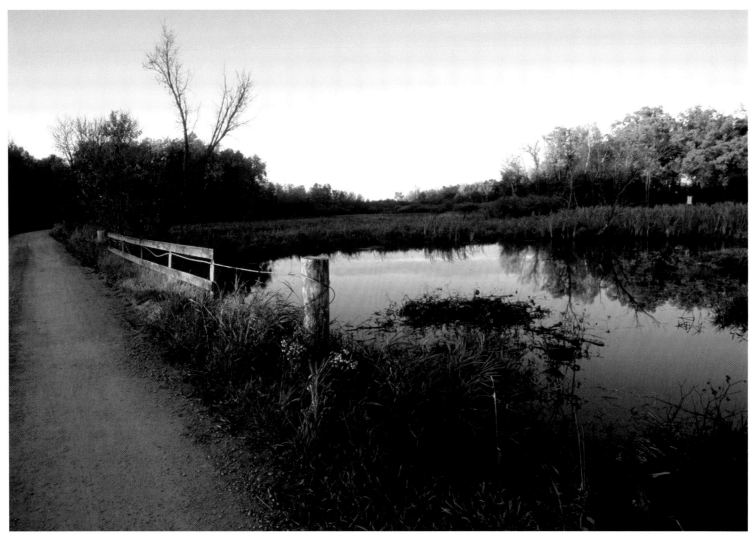

Fall. Rustic Road 22, Green Lake County.

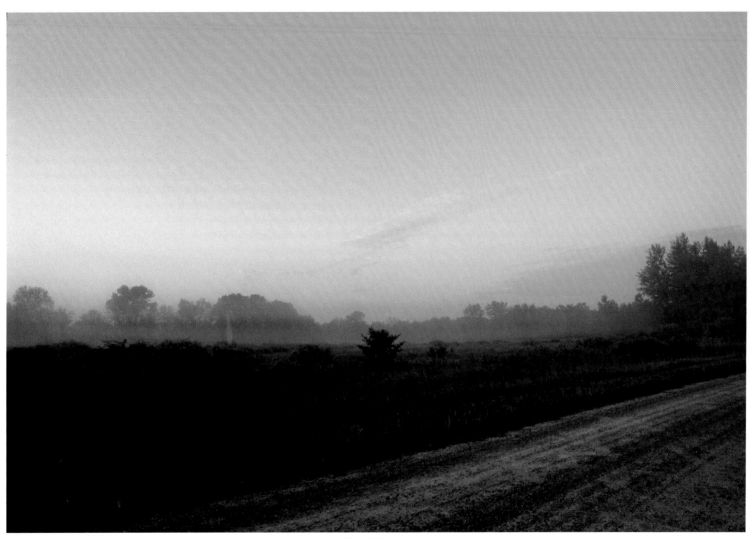

Summer, Rustic Road 22, Green Lake County.

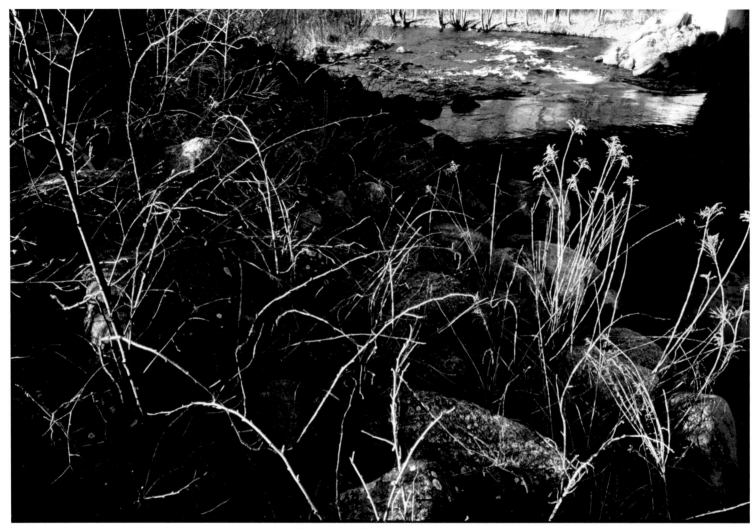

Under the Cobbtown Road Bridge,
Rustic Road 57, Waupaca County.

74

The Waupaca River flowing under the Cobbtown Road Bridge.
Rustic Road 57, Waupaca County.

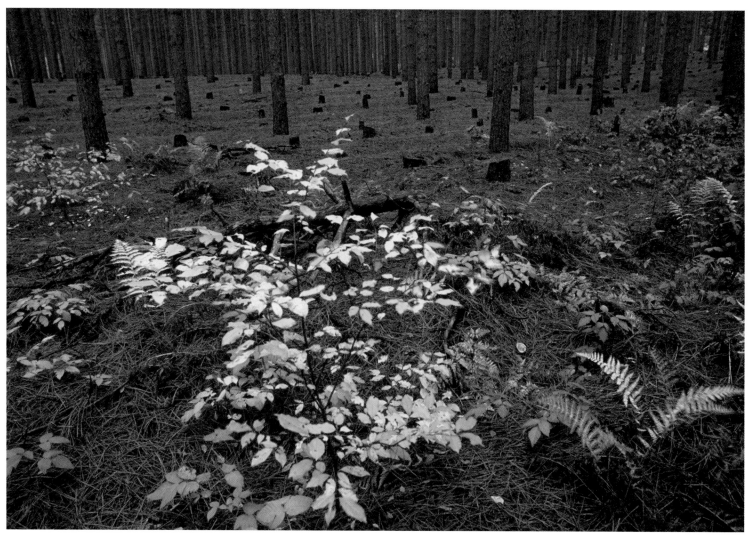

Pine forest and undergrowth, Rustic Road 54, Jackson County.

Fern in pine forest, Rustic Road 54, Jackson County.

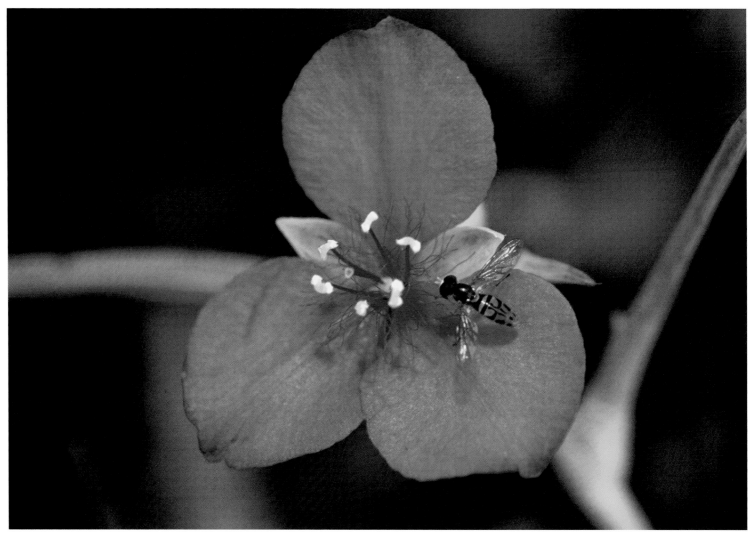

Hover fly on a spiderwort. Levee Road, Rustic Road 49, Sauk County.

Snow melting off tree in the Saxville Hilltop Cemetery.
Rustic Road 45, Waushara County.

79

In Search of the Rustic Road

by *Norbert Blei*

Americans love the road. We are always bound for somewhere, answering its call . . . outside, inside ourselves. Writers in particular are taken by the road's way, whether it be Whitman singing its praises:

> Afoot and light-hearted
>
> I take to the open road,
>
> Healthy, free, the world before me,
>
> The long brown path before me
>
> leading wherever I choose.

Or Kerouac and his hipsters maniacally pursuing it cross-country, spiritual vagabonds searching for a new holy order of the highway, seeking solace and soul in movement, digging the layers of landscape and culture, exploring a

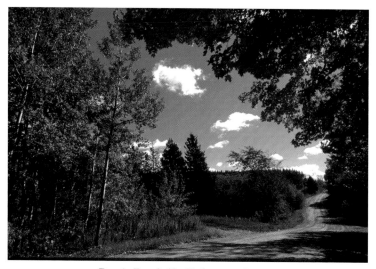

Rustic Road 63, Sheboygan County.

higher consciousness of just Being, just being "there:" on the road again…What's your road, man?—holyboy road, madman road, rainbow road, guppy road, any road. It's an anywhere road for anybody anyhow.

Or Robert Frost in New England, pondering a matter of choices

> —two roads diverging in a yellow wood,
>
> the one less traveled by, the one not taken.

Wisconsin writers, too, have heeded the call: Glenway Wescott, taking the road out of town early—Good-Bye Wisconsin. Hamlin Garland moving along the Main-Traveled Roads: Follow it far enough, it may lead past a bend in the river where the water laughs eternally over its shallow . . . Mainly it is long and wearyful

. . . Like the main-travelled road of life.

And still other Wisconsin authors, rural routing the home turf while perfectly content to stay in place, confined to countryside. Lorine Niedecker, bringing her small world of Blackhawk Island into a poet's peculiar vision. Peering into the smallest particulars. Reducing daily life to a few choice words:

I walked

on New Year's Day

beside the trees

my father now gone planted

evenly following

the road

Each

spoke

And Sac Prairie's chronicler, August Derleth, whether on foot (a walker in its lanes and byways…a walker bent upon knowing the least bird) or by car (I often rode through the hours of the evening and night along country roads, taking pleasure in the night, in the nocturnal sounds so common to the summer evenings—the lowing of cattle, the barking of dogs, the crying of whippoorwills and killdeers, the calling of frogs, the stridulations of katydids and crickets—and in the perfumes of the darkened countryside). A writer surely at home, at peace, and a part of the interior byways of Wisconsin, in persistent dialogue with his native, natural setting.

It has been said by visionaries and artists alike that everything is there before we discover it. So true of the road, in all of its manifestations, all of its directions, and all of its

subtle attractions. I am continually reminded of this in my present location, Door County, Wisconsin, where I settled in 1969, following the road's way. Where I continue to heed the road's call, discovering other directions and new distances.

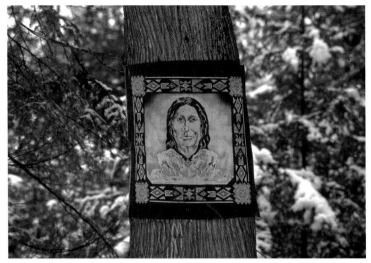

Face of an American Indian on a tree.
Cana Island Road – Rustic Road 38, Door County.

with it on some level of awareness from behind my desk window: weather; the seasonal variations of white birch, cedar, and green or gold maple woods the road divides; animal and bird life—fox, coyote and deer, grouse, hawk, and pileated woodpecker.

Outside the window of the old chicken coop where I write lies a road that appears woven through my woods, always in sight but for winter-white, when it vanishes in the terrain. A road rural and rustic enough to invite my devoted attention. I know all its promises, every hour of the day, every season. I know how it dead-ends like a dream in a small, clear lake only a short distance away. We keep a watch on each other. Not a day passes that I don't connect

The road continually captures my attention, carrying me with it from my window. What's happening on the road now? Local traffic. A neighbor going to town. The county patrol car on its late afternoon run. Mail delivery. A stranger running (from where? to where?). The sudden burst of the orange snowplow in winter. The surfeit of summer traffic, when the road seems to sacrifice much of its character to tourists agog in ruralness, losing the isolated

identity that I revere—except late at night, when the road reclaims its innocence in darkness.

The road turns inner before one's very eyes, when one least expects it—even from a distance, behind glass. "My road," as I've come to perceive it, to know it, to love it, becomes a meditation: My eyes wander, pause periodically, then fix on some new journey to the creative interior. Images appear. Places make themselves known. Characters speak. Silence becomes prayer. Stories make their way. I am both "lost" and on the road again, on another journey. Not unlike Black Elk's red road, "the sacred road," where harmony is restored.

Experiencing the road (the true road, the rustic road, "my road") underfoot, as I do every day and night, is yet another dimension of interior travel, which only the poet in us truly comprehends. There's a light to my road at times not entirely explainable or believable. Morning and late afternoon light, especially, mixing with the natural intangibles of dew, ground fog, hoarfrost, ice storms, soft rain, mist, summer showers, late afternoon snowflakes drifting against a large vermillion sun that descends visibly/invisibly, almost touchable, pulling a gray-blue blanket of evening over the vanishing day as the walker treks west toward the diminishing glow just before darkness. A darkness just light enough for a man to negotiate his direction and return. A darkness of pitch-black night and almost losing the way back, if it weren't for the feel of the pavement under his foot and the memory of just how the road lies.

Bright nights. Northern lights—the great white way. Broadway comes to the countryside. Dog-howling full moon nights. Light rises from the lake, spilling over barns and silos, woods and fields, pouring onto the road's way—Moon River white. The road is transformed. Only the walker understands where a road might lead in darkness, and how he might lose and find himself each step of the way.

I was on my road again this morning, only minutes ago, just before sunrise, destination nowhere (the road's dead end—the mystery of water), lost in the golden light of maple leaves showering my steps. In 25 years I have never tired of this road, always leading me somewhere I haven't been and showing me something I haven't seen before. A road once dirt, then gravel, now blacktop. Some mornings I walk it forgetting the blacktop, feeling for the earth of the road's shoulder. I imagine an early settler making a first pathway through woods and field, suddenly stopped in his tracks as I stop in mine at the road's end, which opens into the liquid light of a luminous, small lake at one's feet.

My journey down this road, my history on this peninsula, is relatively brief. My point of reference in the past was always the street. Roads evoked neither this sense of nature or reverence where and how I once lived. My road here these past years has led to a new perspective. A map to the interior which I continue to read to better orient myself.

I have been, and in ways will always remain, a stranger to this terrain. Before the rustic road, the country road, the back road, and the dirt and gravel road, the nearest avenues I can call to mind are the alleyways of my Chicago neighborhood—sometimes dirt and cinder, sometimes brick, but mostly broken concrete.

Alleyways of adventure ran north and south, inevitably intersecting major thoroughfares. Alleyways occasionally led to prairie lots, where the last vestiges of real nature could still be found—trees to be climbed, weeds to be trampled, earth to be dug into forts and foxholes, sticks to be gathered for weapons or kindling, birds to be hunted with slingshot, bow and arrow, and BB guns. There were garden snakes to be caught and flung at the enemy—or killed because they were snakes and cold fear was running in our blood. Nature's prairie call was purely primal. It reduced us to neighborhood savages lost in

paradise—a paradise to be found just down our alleyway, where we freely roamed, alive in our skin in a way we never were on streets and thoroughfares.

Alleyways "rustic" enough in the city sense (despite concrete, garages, garbage cans, telephone poles, and fences) that the backyards on both sides brought true and constant proximity to nature. The backyards of this ethnic Eastern European enclave (of which I was a descendent) were something to behold. Luscious green lawns. Borders of flowers along the sidewalk and floral gardens of every flower and color imaginable (though always the red and white peony, always the red rose). The fruits of apple and cherry trees. Sweet-scented lilac bushes burgeoning with blossoms drowsily hanging over garage roofs and back fences, intoxicating the alley air. Shafts of red, yellow, white, purple, pink hollyhocks. Heavy-headed sunflowers towering beyond a child's reach. Birds—mostly sparrows and robins—perched everywhere. Summer vegetable garden patches of lettuce, radishes, corn, tomatoes, peppers, squash, beans, cabbage, and kohlrabi. Blue and white morning glories twisting their way along wire fences. Roses trailing up white wooden trellises. This was the beauty of nature domesticus, the nearest order of nature to affect our senses as children of the city. The view over backyard fences was our "rustic road," our alleyway.

It's hard to believe that my reverence for nature these

Barn built by early Czech immigrants, still used for animals.
Rustic Road 7, Kewaunee County.

days, my increasingly combative stand for preservation of the rural landscape, began in the back alleys of the old neighborhood on the west side of Chicago. But when I penned a satiric column sometime ago called "Shut the Damn Door," a Master Plan designed to control rampant tourism and the exploitation of the natural Door County landscape (which resulted in my dismissal as a columnist), images and feelings from my own back alley were inevitably reflected in my vision of protecting the wild.

Mailboxes surrounded by cut wood. Rustic Road 40, Brown County.

I devoted a section in that semi-serious preservation plan to roads, and I argued, among other things, that no new ones should be constructed anywhere in the county. If you can't get there on the roads we got, you don't need to go. More importantly, all highways, and backroads—or county trunks as we know them (concrete and asphalt)—were to be torn up immediately and returned to their natural state of dirt and gravel—good Door County earth. This would reduce the traffic flow, control the influx of Yuppies in their BMWs, and slowly return us to ourselves—to nature's true accessways to the inner spirit. Needless to say the plan, though entertaining, was never entertained, and I was advised to hit the road—sentenced to exile in his own territory. So much for master plans and roadwork in Door County, Wisconsin.

However, Wisconsin's Department of Transportation, in cooperation with local governments, civic groups, county and town boards, and local residents, had the foresight some years ago to create a system that would spare some of the state's scenic backroads. The Rustic Roads system was created in 1973. Not every county in the state has a road so designated (northern Wisconsin is particularly bereft of such designations), but a number of them do—some as many as three or more. Northeastern Wisconsin, which includes Sheboygan, Manitowoc, Brown, Kewaunee, and Door counties, has only nine Rustic Roads in all. Brown and Door County have three each.

I've driven and walked and studied and thought about all nine of these roads, and I've even returned to

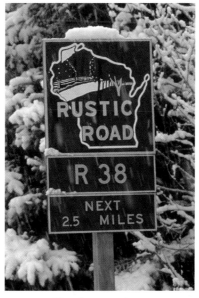

Sign in snowstorm,
Door County.

two favorites outside my county upon occasion. What they all have in common is a call to the rural, a true sense of the Wisconsin landscape leading us into its very heart—what was, what still is, and in some cases, what might have been. What we may be losing before our very eyes, whether it's officially declared rustic or not. I speak of Wisconsin's green and gold fields, maple and pine woods, gentle hills, red-barned farms, and the

solace of water, which gives any road another incomparable spiritual dimension.

Door County's Rustic Road 38, which runs north of Baileys Harbor, then along Moonlight Bay to Lake Michigan's Cana Island Lighthouse, and Manitowoc's Rustic Road 16 from County V to Two Rivers are two roads in particular, both blessed with water near the

road's edge. Meditations upon earth, sky, and lake to lift the traveler's heart. And both are equally blessed with thick woods, with light dropping down between branches and the fresh smell of pine.

Closest to home, Rustic Road 38 begins with swamp and field (wildflowers in full bloom) and winds slowly through woods, thimbleberry plants thick along the road's edge, the road turning, swaying...opening to Moonlight Bay (Mud Bay to the natives), North Bay, shoreline, and the view of Cana Island itself, which appears to move both with you and away from you as you drive towards the little spit of land that eventually connects the traveler to it and the light-house at the road's end. This is by far the most inspiring official Rustic Road in Door County, although there are others (unofficial) that I hold dear to my heart's memory and seek out when I need them.

Rustic Road 39, Ridges Road, retains touches of the rustic, too. It borders the Ridges Sanctuary, an 800-acre treasure in itself of native plant life ranging from fringed gentian to 25 species of native orchids—much of this often visible from the road's way. There is also beach frontage to behold and some breathtaking glimpses of water, but a new condo development at the beginning of this road mars the initial impact and foreshadows more bad news ahead. As the road turns, one is faced with the realities of change—a yacht club, condos, and more development under way—a busyness inevitably diminishing what once was, destructive to the overall tranquility we expect a rustic road to provide.

The real beauty and rusticity of this road begins where the pavement ends. A gravel, tire-rutted roadway/pathway leads to the Toft Point Natural Area and the true wonder of earth underfoot:

...wildflowers, scent of pine, animal life, stone, sand, and the music of water. The way it used to be.

Rustic Road 9, known as Glidden Drive or County T

This is the road we are always searching for.
The one leading us into and beyond ourselves.

Fall. Rustic Road 63, Sheboygan County.

in Door County, is another study of Rustic Road "progress." As real as it was years ago, traversing woods and dunes and streams and shoreline at the time of its official designation, its wonders will seem diminished to any real rustic road lover today.

Given the ongoing development along Glidden Drive of condos and private homes named "Trail's End," "Surf Sound," and "Sherwood Forest" (a sure sign that rural has given way to romance), and given the visible forms of animal life (a well-groomed poodle with a red bow on its head walking down the road), Rustic Road 9 is about as rustic as Whitefish Bay, Wisconsin, or Kenilworth, Illinois. This is upscale suburban sprawl. This is a road that should proba-

Driveways on Glidden Drive. Rustic Road 9, Door County.

bly be redesignated from rustic to country cute.

At present I find myself stranded on a road with mixed feelings. I'm grateful that such a program of road preservation exists in the state of Wisconsin, yet I'm concerned about rustic roads that lose their character over time because of the inroads of man. The Rustic Roads program may carry the seeds of its own destruction in its very celebration of that which we wish to preserve. It encourages more traffic.

How to preserve? How to share?

In the end, we are all left with those roads, real or remembered, that carry us home—back to the true nature of ourselves. Roads we may not even wish to share,

entrusting them only to ourselves for solitary safekeeping—private roads.

Roads perhaps public but essentially private, like Kewaunee County's Rustic Road 7, which leads inevitably to the solitary quest of self-discovery. Here is one of the few (partially) gravel roads so reminiscent of the past. Find yourself on this road and you're on your way. A road of old pine, thistle, farms, a fieldstone barn, and a small bridge crossing a creek. Cottonwood trees. A flour mill. A sawmill. Wild apple, wild grape, wild aster. Wild and real and old Wisconsin. A road that transports, but also lifts us beyond the surface to places almost ethereal.

This is the road we are always searching for. The one leading us into and beyond ourselves.

Stand by the roads, and look, and ask for the ancient paths, where the good way is, and walk in it, and find rest for your souls.

—*Jeremiah 6:16* 🐌

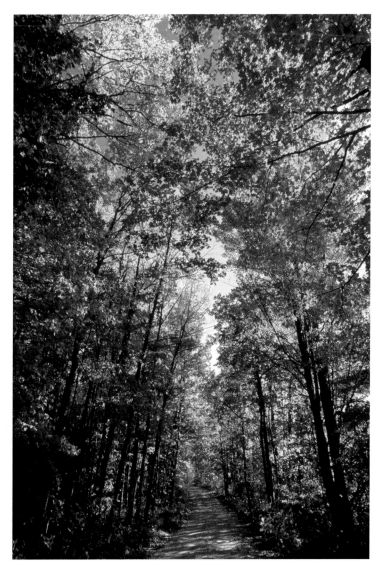

Rustic Road 7, Kewaunee County.

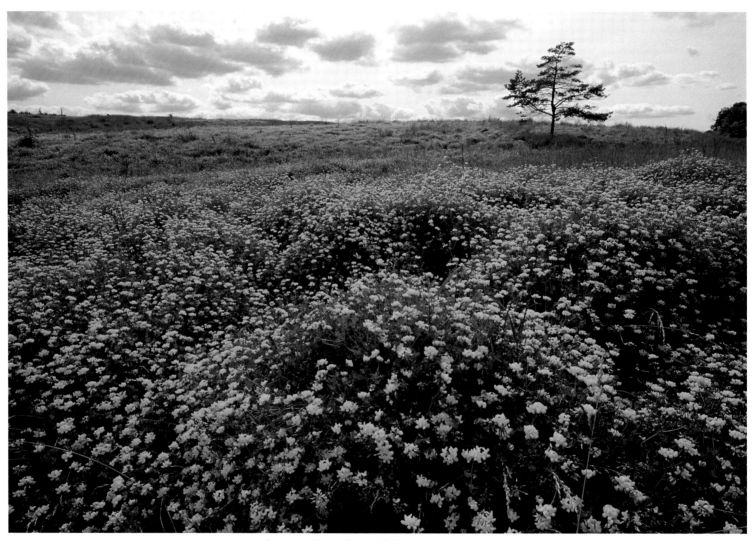

Summer. Rustic Road 63, Sheboygan County.

Driftwood and grass, Point Beach State Park.
Accessible only from Rustic Road 16, Manitowoc County.

Tree and abandoned farm machinery.
Rustic Road 7, Kewaunee County.

Sumac growing through the ruins of an old barn.
Rustic Road 7, Kewaunee County.

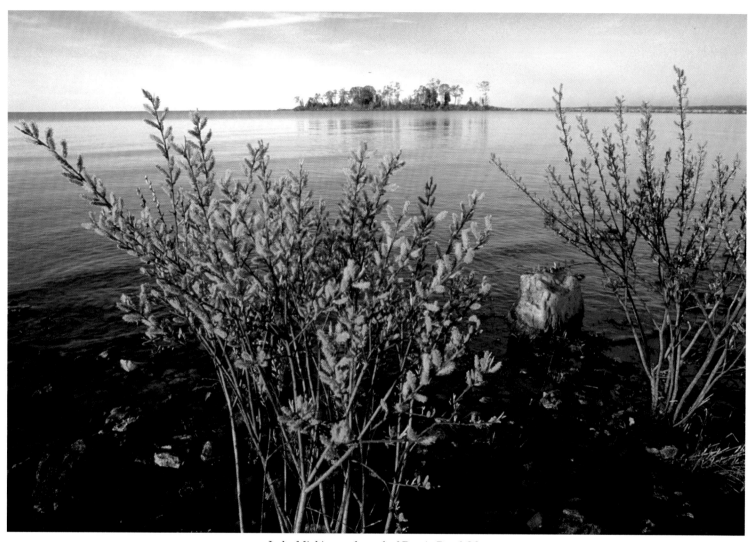

Lake Michigan, the end of Rustic Road 39,
Door County.

96

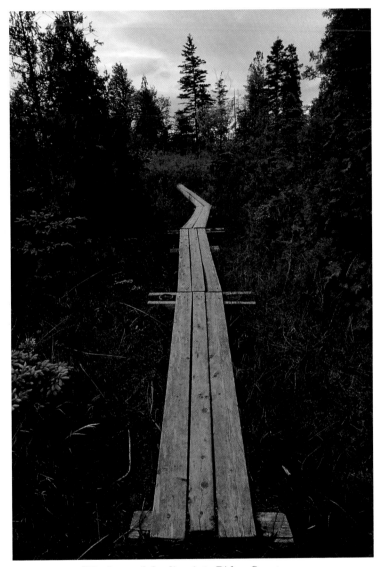

Wooden path leading into Ridges Sanctuary.
Ridges Road – Rustic Road 39, Door County.

97

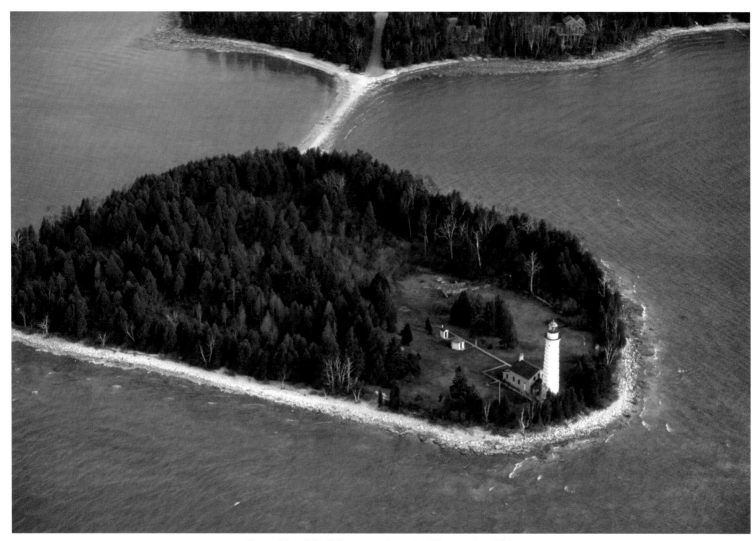

Cana Island Lighthouse at the end of Rustic Road 38,
Door County.

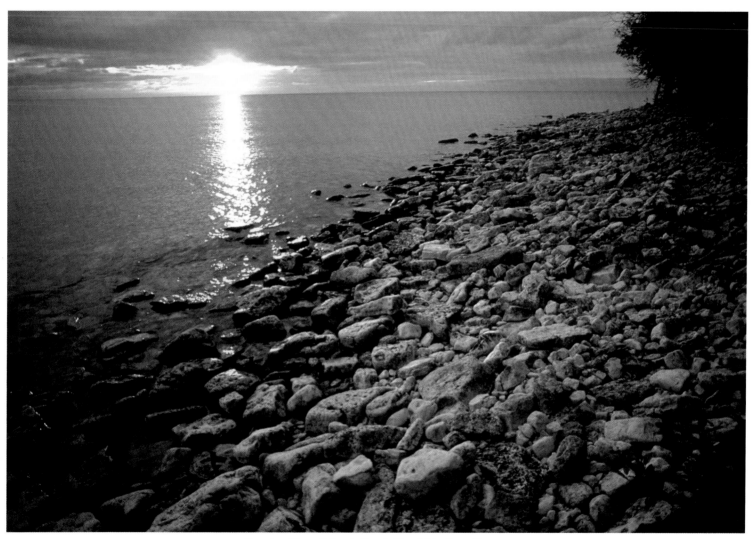

Sunrise, Cana Island. Rustic Road 38, Door County.

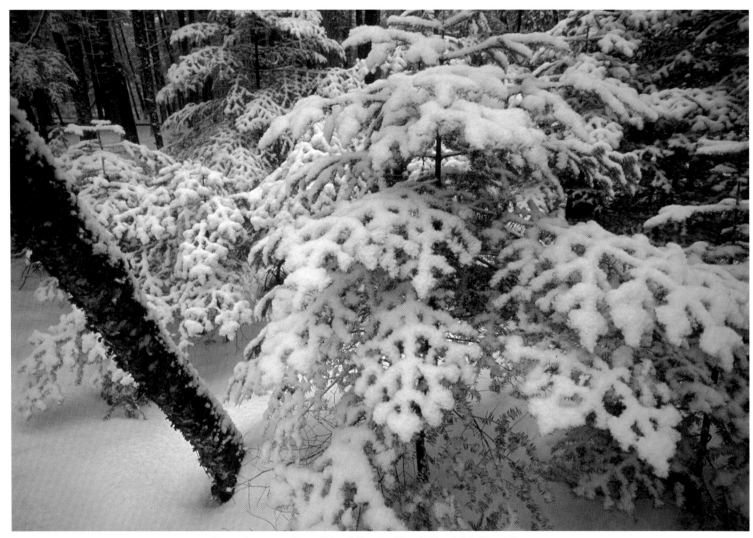

Forest in snow. Cana Island Road – Rustic Road 38, Door County.

Wisconsin's Rustic Roads
How They Came To Be

The Rustic Roads System in Wisconsin was created by the 1973 State Legislature in an effort to help citizens and local units of government preserve what remains of Wisconsin's scenic, lightly traveled country roads for the leisurely enjoyment of bikers, hikers and motorists.

Ribbon Cutting Ceremony for Rustic Road 66 in Lafayette County. Official participants are (from left to right): Tom Carlsen, DOT District Director; Tom Solheim, Chair, Rustic Roads Board; Marybell Whale and Malcolm French, both of the Fever River Economic Group; Wayne Wilson, Chair of the Lafayette County Board; and Rep. Steve Freese, 51st District.

travel through some of Wisconsin's most scenic countryside.

A small placard beneath the Rustic Road sign identifies each Rustic Road by its numerical designation within the total statewide system. Each Rustic Road is identified by a 1- to 3-digit number assigned by the Rustic

Unique brown-and-yellow signs mark the routes of all officially designated Rustic Roads. These routes will provide bikers, hikers and motorists an opportunity for leisurely Roads Board. To avoid confusion with the State Trunk Highway numbering, a letter "R" prefix is used, such as R50 or R120. The Department of Transportation pays the cost

of furnishing and installing Rustic Roads marking signs.

An officially designated Rustic Road shall continue to be under local control. The county, city village or town shall have the same authority over the Rustic Road as it possesses over other highways under its jurisdiction.

A Rustic Road is eligible for state aids just as any other public highway.

Program Goals

- To identify and preserve in a natural and essentially undisturbed condition certain designated roads having unusual or outstanding natural or cultural beauty, by virtue of native vegetation or other natural or man-made features associated with the road.

- To provide a linear, park-like system for vehicular, bicycle and pedestrian travel for quiet and leisurely enjoyment by local residents and the general public alike.

- To maintain and administer these roads to provide safe public travel, yet preserve the rustic and scenic qualities through use of appropriate maintenance and design standards, and encouragement of zoning for land use compatibility, utility regulations and billboard control.

What is a Rustic Road?

To qualify for the Rustic Road program, a road

– Should have outstanding natural features along its borders such as rugged terrain, native vegetation, native wildlife, or include open areas with agricultural vistas which singly or in combination uniquely set this road apart from other roads.

– Should be a lightly traveled local access road, one which serves the adjacent property owners and those wishing to travel by auto, bicycle or hiking for purposes of recreational enjoyment of its rustic features.

– Should be one not scheduled nor anticipated for major improvements which would change its rustic characteristics.

– Should have, preferably, a minimum length of 2 miles and, where feasible, should provide a completed closure or loop, or connect to major highways at both ends of the route.

A Rustic Road may be dirt, gravel or paved road. It may be one-way or two-way. It may also have bicycle or hiking paths adjacent to or incorporated in the roadway area.

The maximum speed limit on a Rustic Road has been established by law at 45 mph. A speed limit as low as 25 mph may be established by the local governing authority.

What You Can Do …

As you drive around the Wisconsin countryside, think of roads you would like to see included as part of the Rustic Roads system. Inventory Rustic Road candidates in your area. Then follow up with talks to local residents and government officials.

Initiate and circulate petitions among resident property owners along your favorite road to have it designated a Rustic Road. Work with civic, recreational and environmental groups to publicize and encourage the success of the Rustic Roads program.

Information may be obtained by contacting your town chairman, county highway commissioner or one of the Rustic Roads Board personnel. To obtain necessary forms and further information, you may also contact:

The Rustic Roads Board
Wisconsin Department of Transportation
P.O. Box 7913
Madison, WI 53707

❧ THE DESIGNATION PROCESS ❧

County Roads:

1. Petitions, from resident landowners along the road or in the county in which the road lies, are obtained and presented to the County Highway Committee. The process can also be initiated by resolution of the County Highway Committee.

2. The county Highway Committee offers to hold a public hearing on the proposed Rustic Road designation.

3. Upon approval of the designation, the County Highway Committee requests approval of the Rustic Roads Board. In requesting approval of the Rustic Roads Board, the County Highway Committee should supply photos or slides of the road, showing its qualifications, along with the information outlined on the Rustic Road Description Form.

4. The Rustic Roads Board reviews the application and

has final approval authority over the designation. Its approval makes the designation official.

Town, Village, City roads:

1. Petitions, from resident landowners along the road or in the municipality (town, village or city) in which the road lies, are obtained and presented to the governing body of the municipality. The process can also be initiated by resolution of the governing body.

2. The governing body offers to hold a public hearing on the proposed Rustic Road designation.

3. The governing body, upon approval of the designation, requests approval by the Rustic Roads Board. In requesting approval of the Rustic Roads Board, the governing body should supply photos or slides of the road, showing its qualifications, along with the information outlined on the Rustic Road Description Form.

4. The Rustic Roads Board reviews the application and has final approval authority over the designation. Its approval makes the designation official.

 The designation processes described in this chapter are intended to show the general steps involved in obtaining a Rustic Road when no jurisdictional change is desired. Oftentimes, a jurisdictional change (local road becomes a county highway or vice versa) will be desired. Under such circumstances, the jurisdictional change must precede the Rustic Road designation and follow all normal jurisdictional change procedures. Specific rules and procedures on Rustic Road designation may be obtained from the Rustic Roads Board.

Rustic Roads Board

 A 1973 state law created the Wisconsin Rustic Roads Board within the Department of Transportation. This Board is responsible for assisting in the establishment of the Rustic Roads system through development of rules and standards and exercising final approval authority for Rustic Road designation. The 10-member Board represents a broad geographic base within Wisconsin, as well as state, county and local government, utilities and the general public.

♣

(The publisher would like to thank the Wisconsin Department of Transportation for providing this information and that in the following chapter.)

Sign at the end of Rustic Road 53, Outagamie County.

Finding Your Way - The Maps

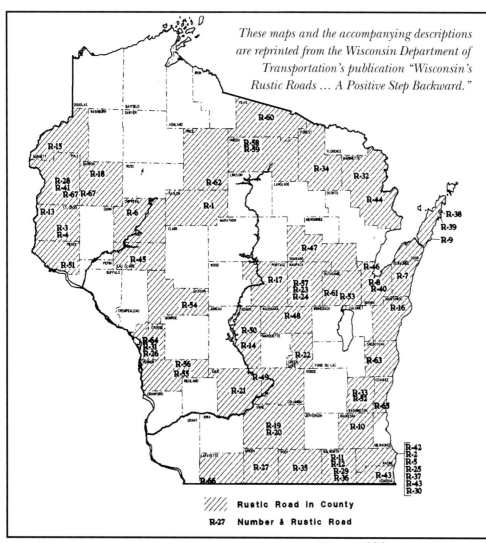

These maps and the accompanying descriptions are reprinted from the Wisconsin Department of Transportation's publication "Wisconsin's Rustic Roads ... A Positive Step Backward."

///// **Rustic Road in County**

R-27 **Number & Rustic Road**

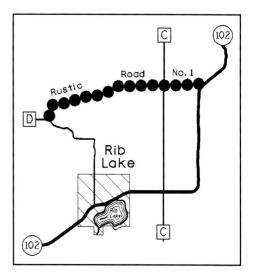

R-1

Location: Taylor County, between WIS 102 and County Highway D near Rib Lake.

Length: 5 miles **Surface:** Gravel

This is the first Rustic Road and was dedicated in 1975. A historical marker alongside the road commemorates the designation. In close proximity to four lakes, this road offers many opportunities for recreation: a non-denominational youth camp, bathing beach, public boat landing, resort with refreshments and boats for rent, and a scenic overlook featuring a beautiful panorama of forest and lake. Watch for samples of native flora and fauna along the entire length of this roadway.

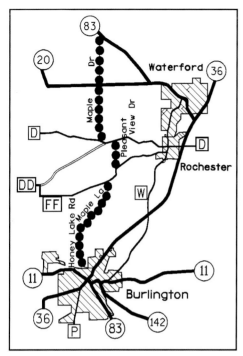

R-2

Location: Racine County. North from Burlington along Honey Lake Road, Maple Lane and Pleasant View Road to County Highway D, continuing north along Maple Drive to WIS 83.

Length: 7.9 miles **Surface:** Paved

Under a canopy of trees, this route provides vistas of rolling fields and dairy farms. There is a marsh with waterfowl, muskrat houses and other wildlife in the Wehmhoff Woodland Preserve.

R-3

Location: St. Croix County. Rustic Roads 3 and 4 begin at WIS 128 and follow the outer edges of a watershed and county park. R-3 is Jerdheim Road between WIS 128 and County Highway E, south of Glenwood City (see R-4 map).

Length: 3.6 miles **Surface:** Paved

This narrow road borders the heavily wooded Glen Hills Watershed park area, as well as privately owned farmland. The blacktop road curves over many hills, with open views of farmland on either side. Picnic at the nearby county park, or enjoy the beach on Beaver Creek.

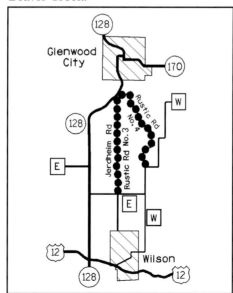

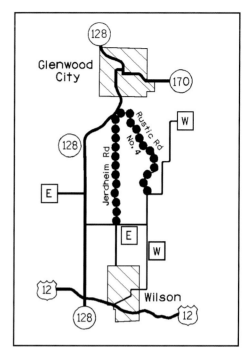

R-4

Location: St. Croix County. South of Glenwood City beginning at WIS 128 south to its intersection with County Highway W.

Length: 4.6 miles **Surface:** Gravel

R-4 runs south parallel to R-3 and borders the east side of the Glen Hills Watershed Park area. Beautiful fall colors along with many coniferous trees are visible from this route. Watch for glacial rock formations. This area is also known as wild turkey country.

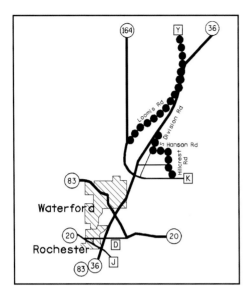

R-5

Location: Racine County. Loomis Road beginning at WIS 164, north to Fries Lane and the intersection of Fries Lane and WIS 36.

Length: 3.1 miles **Surface:** Paved

Loomis Road was originally laid out as a territorial road in 1840 and retains many of its original rustic lines. This route passes Col. Heg Memorial Park which commemorates Wisconsin's top ranking officer killed in action during the Civil War. A museum there emphasizes the heritage of a group of Norwegian settlers and their contribution to Wisconsin's development. There is also a small log cabin in the park which was built in 1837.

R-6

Location: Chippewa County. County Highway E, from the junction of WIS 64 north to the Chippewa County - Rusk County line.

Length: 13.3 miles **Surface:** Paved

This rustic road is part of the old Flambeau Trail, an important route for early settlers who wished to reach the north. The road traverses through county forest lands and a part of the Ice Age National Scientific Reserve in Chippewa County.

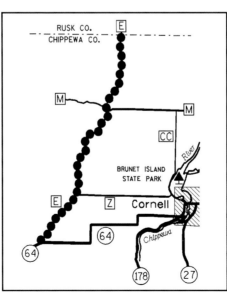

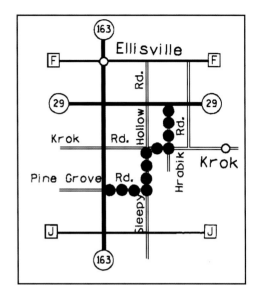

R-7

Location: Kewaunee County. Includes portions of Hrabik Road, Cherneysville Road, Sleepy Hollow Road, and Pine Grove Road between WIS 29 and WIS 163.

Length: 3.5 miles

Surface: Paved and gravel

This route wanders past the remains of an old lime kiln, travels through glacial deposits, and affords views of an old German home, an old flour mill, and several picturesque barns.

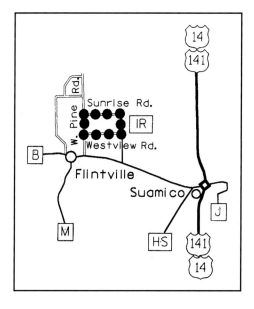

R-8

Location: Brown County. Northeast of Flintville, R-8 makes a loop off County IR (Reforestation Road), following Sunrise Road, Pine Lane and Westview Road.

Length: 3 miles
Surface: Paved and gravel

Located between Flintville and Suamico, R-8 wanders between stands of hardwood and coniferous trees that stretch along its length near a county park.

R-9

Location: Door County. County Highway T (Glidden Dr.), between Brauer Road and Whitefish Bay Road.

Length: 6.7 miles **Surface:** Paved

Located along the Lake Michigan shore, this route passes through sand dunes, heavy forest, and streams that are natural spawning grounds for trout and smelt. Other sites include an old sawmill, fishing site, log cabin and a panoramic view of Lake Michigan with a beautiful sand beach.

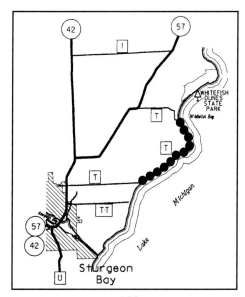

R-10

Location: Waukesha County. R-10 includes portions of County Highway B (Valley Road) and Mill Road between Main Street and Sawyer Road.
Length: 3.3 miles **Surface:** Paved

This curving trail rides the narrow isthmus between Upper and Lower Nashotah Lakes and runs south past Upper Nashotah Lake. The broad fields of Pabst Farms and the remainder of its once-famous dairy barns lie to the west. To the north of Mill Road, the red-tiled spires and gables of Nashota House Seminary can be seen.

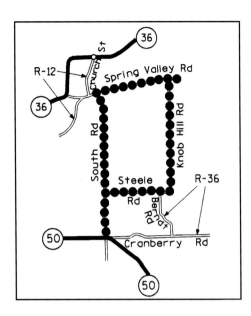

R-11

Location: Walworth County. To the east of Lake Geneva, R-11 includes South Road, Steele Road, Spring Valley Road and Knob Hill Road between WIS 50 and WIS 3 adjoining R-12 & R-36.

Length: 10.31 miles **Surface:** Paved

This gently winding route provides excellent views of glacial Kettle Moraine topography, passing through large wooded areas of oak, maple and hickory, with glimpses of rustic rail fences, a game farm and scenic agricultural land.

R-12

Location: Walworth County. This route includes Back Road, Sheridan Springs Road, Spring Valley Road and Church Road, between WIS 50 and WIS 36 adjoining R-11 & R-36.

Length: 5.7 miles **Surface:** Paved

At various points the road offers panoramic views of lush green hills and valleys. The sharply curving route passes outstanding Kettle Moraine formations, pine and spruce plantations, a tamarack swamp, and several ponds. R-12 crosses the White River and runs through the community of Lyons with its several quaint churches.

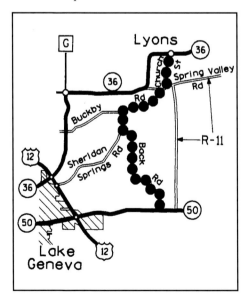

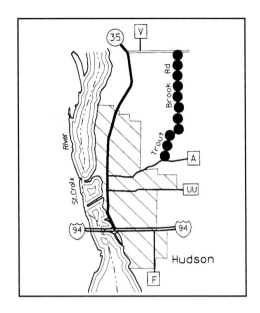

R-13

Location: St. Croix County. Trout Brook Road between County Highway A and River Road.

Length: 3 miles
Surface: Paved

The third road to be designated in St. Croix County passes through hilly terrain across the scenic Willow River. This route meanders through heavily wooded areas past several artesian wells.

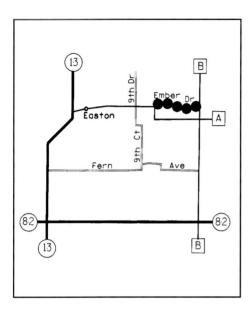

R-14

Location: Adams County. Ember Drive between County Highway A and County Highway B.

Length: 2 miles

Surface: Gravel

This thickly forested area supports a multitude of wildlife and wildflowers. the road winds up through a cleft on top of a bluff. A natural spring runs from the top of the bluff down the side of the road to the east.

R-15

Location: Burnett County. Adjoins St. Croix River State Forest south of WIS 70 near Grantsburg. R-15 includes River Road and Skog Road between Fish lake Road and Kickerson Road.

Length: 5.4 miles

Surface: Paved and gravel

Adjacent to the St. Croix River Forest and the Fish Lake Wildlife Area, this route offers vistas of beautiful coniferous and hardwood trees. Several hiking trails branch off from the road. R-15 is also within a quarter mile of the St. Croix River, part of the U.S. Wild and Scenic River System.

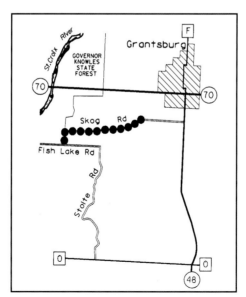

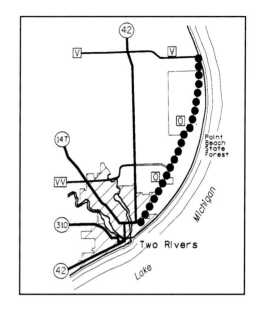

R-16

Location: Manitowoc County. Sandy Bay Road runs along Lake Michigan from County Highway V, south to the corporate limits of Two Rivers.

Length: 5.2 miles

Surface: Paved

This gently winding route runs through Point Beach State Forest, bordered on either side by thick groves of deciduous and coniferous trees. Sandy Bay Road offers many glimpses of birds and other wildlife, as well as open vistas of natural sand dunes, including juniper bushes and other types of shrubbery.

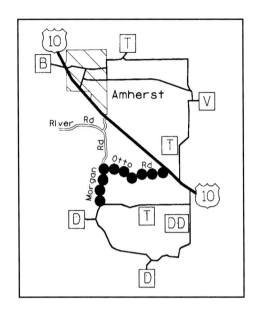

R-18

Location: Barron county. Beginning at County Highway M, R-18 follows Gehler Road (23rd Street) south to 15 3/4 Ave., returning again to county Highway M.

Length: 4.8 miles
Surface: Paved and gravel

Dense stands of white oak, aspen and birch line this narrow rustic road. The nearly five-mile loop begins and ends on County Highway M.

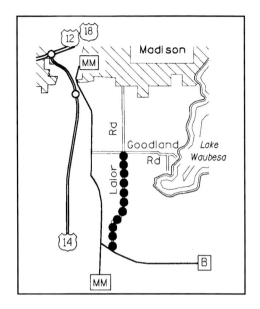

R-17

Location: Portage County. Otto Road from U.S. 10 west to Morgan Road, then south on Morgan Road to Count Highway T.

Length: 2.7 miles **Surface:** Paved

This scenic route south of Amherst passes through hilly, rugged terrain and forested areas as well as open agricultural areas, offering glimpses of native wildlife. R-17 also crosses a boulder-strewn section of the Tomorrow River.

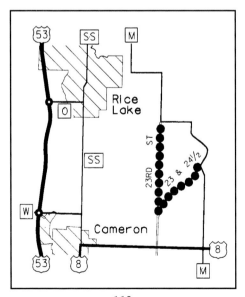

R-19

Location: Dane County, North from County Highway B on Lalor Road to Goodland Park Road.
Length: 2.3 miles **Surface:** Paved

Bordered on either side by native prairie plants, including numerous stands of wild plum and scattered wild asparagus, R-19 crosses Swan and Murphy Creeks and borders the Waubesa Wetlands Preserve. Set back in the evergreens along one side of the road is the William Lalor Farm, originally purchased from the government in 1846. The original deed was signed by President James Polk.

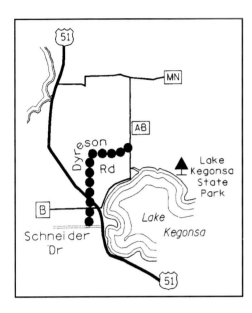

R-20

Location: Dane County, Dyreson Road, from Schneider Road north to County Highway AB.

Length: 2.9 miles **Surface:** Paved

Rich in heritage, Dyreson Road travels through fertile farmland and wooded areas. It offers an excellent view of Lake Kegonsa as it crosses County Highway B. Historic Dyreson bridge over the Yahara River is the site of early Indian and pioneer crossings and is adjacent to ancient Indian effigy mound sites. Also located on the road is Dyreson House, an early Wisconsin homestead listed in the Wisconsin State Historical Society's Inventory of Historic Places.

R-21

Location: Sauk county. Just off County Highway PF, follows portions of Schara Road, Ruff Road and Orchard Drive, near Natural Bridge State park.

Length: 6.2 miles **Surface:** Gravel

Ruff Road and Orchard Drive are narrow, gravel roads that wind through rolling, rugged terrain near Natural Bridge State Park, where the Raddatz rock shelter – the oldest documented site of primitive man's presence in the upper Midwest – is located. Schara Road extends along a ridge bordered by oaks, maples, basswoods and hickories. Remains of an old barn and home foundation are visible from the road.

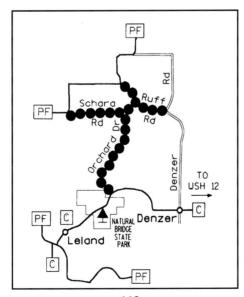

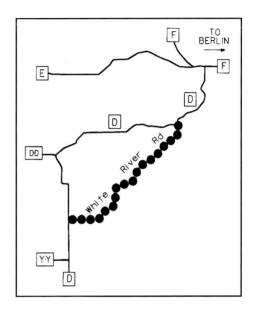

R-22

Location: Green Lake County. white River Road from County Highway D to Big Island Road, north of Princeton.

Length: 5.5 miles
Surface: Gravel and paved

This picturesque road passes through Department of Natural Resources' natural woodland and water areas. Abundant with wildlife, this road features two rustic plank bridges along the way.

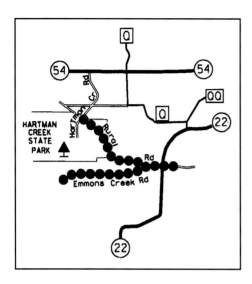

R-23 & R-24

Location: Waupaca County. R-23: begins in the Town of Rural and travels west on rural Road through Hartman Creek State Park, ending at Hartman Creek Road. R-24: Emmons Creek Road, extends west from Rural Road to the Portage County Line.

Length: R-23: 3.6 Miles R-24: 2.7 miles
Surface: Paved and gravel portions

Scenic Rural Road crosses the Crystal River three times over picturesque stone bridges, offering pleasant vistas of agricultural and forest areas. Emmons Creek Road crosses a spring-fed trout stream and passes through several stands of native pine and hardwoods.

R-25

Location: Racine County. Oak Knoll Road from County Highway DD to its junction with County Highway D.

Length: 2.6 miles **Surface:** Paved

Adjacent to the Honey Creek Wildlife Area, this road passes the Franklyn Hazelo Home (c. 1858), listed on the National Register of Historic Places.

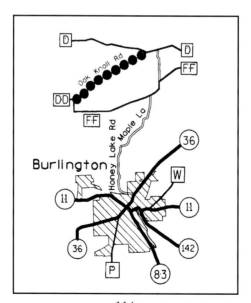

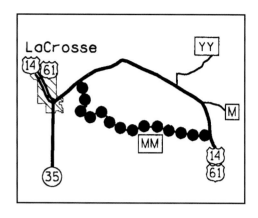

R-26

Location: La Crosse County. County Highway MM, beginning at the intersection of US 14 and US 61 east to its intersection once again with US 14 and US 61.

Length: 5.3 miles **Surface:** Paved

La Crosse County Highway MM combines beautiful scenery and history, offering the traveler views of the Mississippi River Valley and the Mormon Coulee Creek Valley. "Brinkman's Ridge" provides a wide panorama of the Mississippi River, including Goose Island Wildlife Refuge and Minnesota's bluffs. Temperature inversions and low-lying fog in the spring and fall often create surrealistic landscapes that reveal only isolated bluff tops in a sea of mist for the lucky traveler. This route also passes by the Oehler mill site first built in 1854.

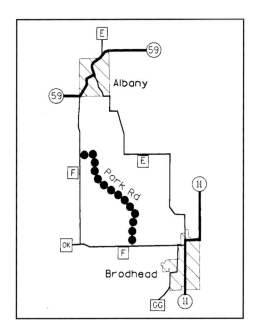

R-27

Location: Green County. Park Road forming a loop off of County Highway F.

Length: 4.3 miles **Surface:** Paved

Along this scenic and historic route you will find the Decatur Town Monument historical marker, the site of Indian camps, the oldest home in Decatur, and the Decatur Lake and dam. With its excellent views of high bluffs and dense woods, Park Road travels through some of the most beautiful landscapes in the area. The Sugar River State Bicycle Trail is located nearby.

R-28

Location: Polk County. Mains Crossing (old Highway 8), beginning at the intersection of County Highway H, then extending east to County Highway D.

Length: 5.2 miles
Surface: Paved & gravel

Passing by Apple River Park and across the scenic Apple River, this route is characterized by pleasant views of deciduous forests and open farmland. Located along the route are three small churches, two cemeteries and the Apple River Town Hall.

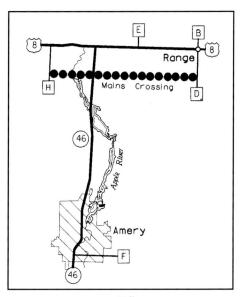

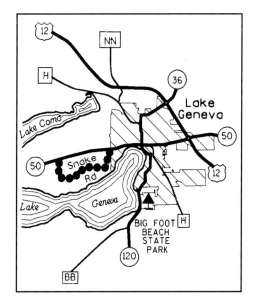

R-29

Location: Walworth County. Snake Road, from the intersection with WIS 50 in the city of Lake Geneva west to the intersection with WIS 50 in the Town of Geneva.

Length: 2.7 miles **Surface:** Paved

This loop is located in a countryside of natural and unspoiled beauty. Sometimes bounded by split rail fence, this road offers the traveler a panorama of colors in the fall as it passes through an area of native vegetation and wildlife near Lake Geneva.

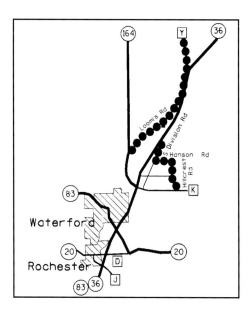

R-30

Location: Racine County. Includes portions of Hillcrest, Hanson, Division and Malchine Roads between County Highway K and WIS 36.

Length: 2.3 miles **Surface:** Paved

This route passes through woods, rolling meadows and lowland marshes, abounding in native vegetation and wildlife. Along the route is a historic one-room school house.

R-31

Location: La Crosse County. Begins at West Salem exit (city loop) off I-90, travels on several streets in village of West Salem to County Highway C, north to State Highway 16, then loops around Swarthout Lakeside Park, back to WIS 16.

Length: 2.6 miles **Surface:** Paved

Rustic Road travelers can view such historic spots as the Gullickson Octagon House, on the National Register of historic Places, and the Hamlin Garland Homestead, where the late Pulitzer prize-winning author did much of his writing. Other points of interest include the former home of Thomas Leonard, founder of West Salem, and Swarthout Lakeside park, a recreation area near Lake Neshonoc.

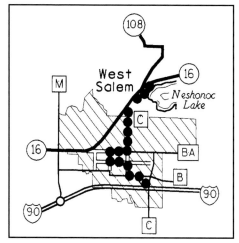

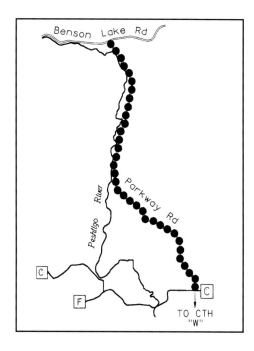

R-32

Location: Marinette county. Parkway Road and Goodman Park Road from County Highway W north to the entrance of Goodman Park

Length: 26.6 miles **Surface:** Paved

Passing through three county parks in addition to county and state forest lands, this road includes vistas of Thunder River, Peshtigo River, High Falls Flowage, and Cauldron Falls Flowage, enhanced by dense woodlands and abundant wildlife.

R-33

Location: Washington County. Portions of St. Augustine Road, Monches Road, Emerald Road and Shamrock Lane; this loop lies between County Highway Q and County Highway K.

Length: 10.6 miles **Surface:** Paved

This winding, hilly route passes through a natural kettle area mainly devoted to agriculture, offering travelers a view of the church spires atop Holy Hill, a well-known seminary in southeastern Wisconsin, open for visits from the public. Another section of the road offers a view of Lowe Lake.

R-34

Location: Forest County. From the Village of Alvin, follows portions of Lakeview Drive, Carey Dam Road and Fishel Road to WIS 70.

Length: 8.8 miles
Surface: Paved & gravel

Located in the Nicolet National Forest, this scenic route includes the Old North Road, the very first road in the Town of Alvin and one which has changed very little over the years. The road leads throughout a heavily wooded area, including a 50-year-old pine plantation, abundant with wildlife and ideal for hunting, fishing, hiking, skiing and snowmobiling.

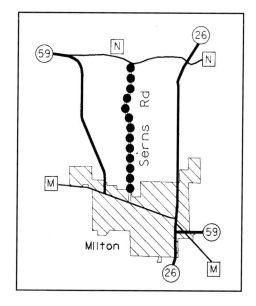

R-35

Location: Rock County. Serns Road between County Highway N and North Jon Paul Road in the Town of Milton.

Length: 2.7 miles **Surface:** paved

Stretching north out of the Town of Milton, Serns Road traverses picturesque and gently rolling agricultural terrain.

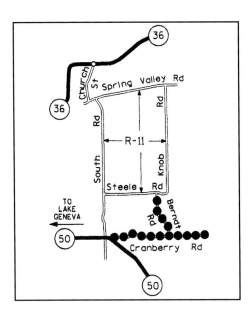

R-36

Location: Walworth County. Includes Cranberry Road and Berndt Road east from WIS 50, adjoining R-11 and R-12.

Length: 3.6 miles **Surface:** Paved

This narrow, hilly route, which obtained its name from the fact that early settlers harvested cranberries from nearby bogs, winds through Wisconsin farmland, glacial marshes and knobs, featuring a wide variety of trees and shrubs.

R-37

Location: Racine County. Three mile Road, beginning at 108th Street east to its intersection with 80th Street.

Length: 1.8 miles **Surface:** Paved

Numerous old oak trees and rail fences border the winding route that has never been widened, nor has its basic course been changed since it was originally laid out in the early 1800's.

R-38 & R-39

Location: Door County. R-38: Cana Island Road extends from its intersection with County Highway Q north to Cana Island. R-39: Ridges Road begins at its intersection with WIS 57 and proceeds northeast to Point Drive and the Old Lighthouse Point Natural Area.
Length: 2.5 miles (both)
Surface: Paved

R-38 passes through a unique boreal forest between Moonlight Bay and North Bay, filled with magnificent specimens of spruce, cedar, white pine and various species of rare plants. Provides scenic views of Cana Island Lighthouse and the Lake Michigan shoreline. R-39 provides panoramic views of heavily wooded and lakeshore areas.

R-41

Location: Polk county. Clara Lake Road between County Highway E and County Highway G.

Length: 2.38 miles
Surface: Paved & gravel

This road wanders past scenic woodlands and farmlands. Clara Lake Road passes the Hunkey Dorey Resort, built in 1902 and still in operation. A canopy of trees shades the gravel portion of this beautiful road.

R-40

Location: Brown County. 70th St. and Clara Lake Drive from County Highway J, west to Pine Tree Road, north to Sunlite Drive, east to Forest Drive, south to Hill Road, then east to County Trunk FF.

Length: 4.6 miles **Surface:** Paved

This rustic road passes near Trout Creek, offering the traveler views of natural woodlands with deep ravines, as well as picturesque open farmland.

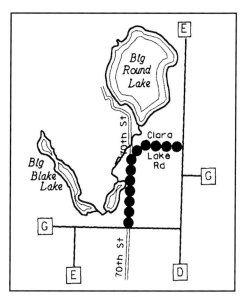

R-42

Location: Racine County. Hoosier Creek Road from County Highway JB to WIS 142 via Brever Road or Wheatland Road.

Length: 5.71 miles **Surface:** Paved

A canopy of large oak and black walnut trees graces Wheatland Road, just south of WIS 142. Travelers to this area will enjoy the open agricultural and marsh vistas in addition to an old brick farmhouse and several barns. Hoosier Creek Road is 1/2 mile away from the Fox River, providing fishing areas and some nice panoramic views.

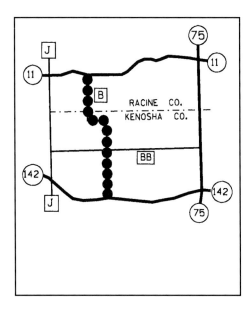

R-43

Location: Racine/Kenosha Counties. County Highway B from the intersection of WIS 142 in Kenosha County to its intersection with WIS 11 in Racine County.

Length: 3.7 miles **Surface:** Paved

Passing through open agricultural land with few residences, this route provides direct access to the Bong Recreational Area.

R-44

Location: Marinette County. Right-of-Way Road from Sumac Lane east to County Highway X. A second branch, South Right-of-Way Road, extends southeast to the Porterfield Lake town line.
Length: 6.5 miles
Surface: Gravel

Right-of-Way Road crosses two creeks and is adjacent to a state wildlife refuge and Marinette County forest land. According to the Loomis Historical Society, R-44 was originally part of the Wisconsin-Michigan Railroad.

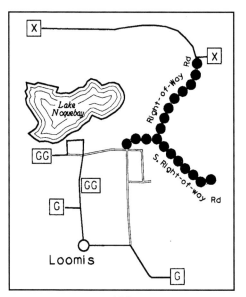

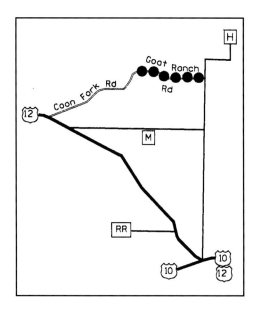

R-45

Location: Eau Claire County. Goat Ranch Road from County Highway H.

Length: 2.7 miles
Surface: Unimproved

This road passes primarily through Eau Claire County forest land. Goat Ranch Road is primitively cut virgin sand surface.

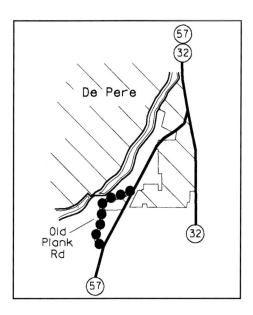

R-46

Location: Brown County. Old Plank Road forms a loop west of WIS 57.

Length: 1.3 miles
Surface: Paved and gravel

Old Plank Road is characterized by ravines, large old trees and a narrow road surface. It dates back to Civil War times when it was used to carry supplies to the Fox River.

R-47

Location: Shawano County. County Highway M, between WIS 29 and US 45.

Length: 14 miles **Surface:** Paved

Featuring open agricultural vistas against a backdrop of wooded hills, R-47 provides the traveler with a canopy of maples over the road, along with historic buildings including a round barn, red granite town hall and a stone filling station. The road crosses two streams and passes conifer glens, wetland vegetation, and rolling fields. County Highway M also passes by the Tigerton Historical Museum and the Wittenburg Historical Museum.

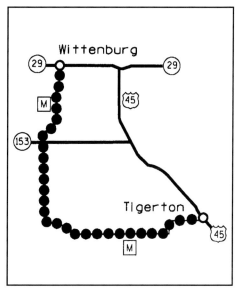

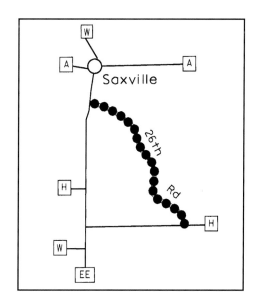

R-48

Location: Waushara County. Twenty-Sixth Road, beginning at County Highway H northwest to County Highway W.

Length: 2.1 miles **Surface:** Paved

This road curves between rolling hills and ground moraines in Wisconsin's central plains region. It passes through the valley of the Pine River, a class II trout stream in a natural state. Much of the agricultural land and fallow fields support ring-necked pheasants, sandhill cranes, deer, red fox, beaver, otter and a wide variety of song birds. A log cabin and two farmhouses, built before the Civil War on 160-acre Homestead Act grants, are visible.

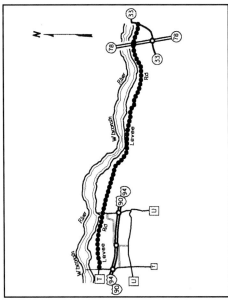

R-49

Location: Sauk County. Levee Road, beginning at the intersection with County Highway T east to the intersection with WIS 33.

Length: 9.8 miles **Surface:** Paved

Travels through the Aldo Leopold reserve along the Wisconsin River, giving motorists, bikers and hikers an opportunity to view prairie grasses, wildlife, trees and marsh in their natural setting. Initially, a portion of Levee Road was designated a rustic road in 1987, in recognition of the 100th anniversary of environmentalist Aldo Leopold's birth. In 1991, the rustic road designation was extended another 7.5 miles.

R-50

Location: Adams county. Cottonville Avenue (Old State Road), from Eighth Drive east to Fourth Avenue.

Length: 4.6 miles
Surface: Unpaved

This road is locally called the State Road because it was laid out by the state, probably in the 1800s. Vistas along this road include native lowland and upland trees, shrubbery and marshes. Wild birds, deer and grouse abound.

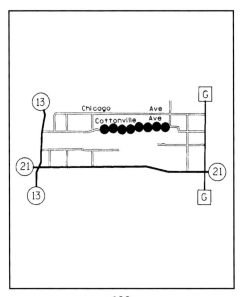

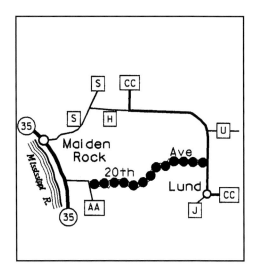

R-51

Location: Pierce County. Portions of 20th Avenue from County Highway CC to County Highway AA.

Length: 4.3 miles
Surface: Gravel

Located near rolling agricultural farmland, this narrow, winding gravel road frequently crosses a trout stream in the midst of dense woodlands. At the intersection of 20th Avenue and County Highway CC is a church dated 1881. Just a few miles south of County Highway CC is a wayside historical marker and the original house where Laura Ingalls Wilder grew up and which she wrote about in the book *Little House in the Big Woods.*

R-52

Location: Washington County. Paradise Drive, Wausaukee Road and St. Augustine Drive from County Highway M east to County Highway Y.

Length: 2.4 miles **Surface:** Paved

This charming wooded road, located on one of the highest points in the county, offers a scenic panorama of the surrounding countryside. Historical features include a log home and an old fieldstone house, both approximately 130 years old. Because of the road's visual appeal, as well as its low volume of traffic, it has been listed in several recreational publications as a suggested bike trail.

R-53

Location: Outagamie County. Portions of Garrity Road, McCabe Road, Greiner Road and Bodde Road between WIS 41 and County Highway JJ.

Length: 4.1 miles **Surface:** Paved

R-53 is located in one of the richest agricultural areas in the Fox Valley. Visitors will find a double-arch bridge, an old schoolhouse which serves as the town hall, a century-old farm, an old stone silo, Apple Creek and a resource conservation area abundant with wildlife. Construction of this road dates back to 1857.

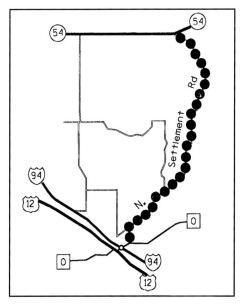

R-54

Location: Jackson County. North Settlement Road, from County Highway O north to WIS 54. Exit off I-94 at the Millston exit.

Length: 12.3 miles **Surface:** Paved

Travels through the Black River State Forest with beautiful pine tree plantations. Follows a portion of the Wazee Trail past Pigeon Creek Campground, numerous flowages, and the Dike 17 Lookout Tower from which miles of marshes are visible. Sandhill cranes, bald eagles, ducks, geese are abundant, as is the variety of plant life, including sphagnum moss beds and native wildflowers.

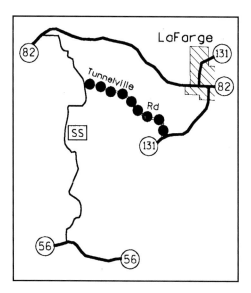

R-55

Location: Vernon County. Tunnelville Road, begins at its junction with WIS 131 to the intersection of Tunnelville Road and County Highway SS.
Length: 2.8 miles
Surface: Paved & gravel

In the spring, Tunnelville Road is characterized by fields of trilliums, while summer lines the steep road edges with ferns and wildflowers. The fall foliage is always colorful and in winter the traveler will appreciate views of the hillsides coated with snow and the wealth of trees along the road.

R-56

Location: Vernon County. Portions of Dutch Hollow Road, Sand Hill Road, Hoff Valley Road and Lower Ridge Road. Begins at intersection of Dutch Hollow Road and WIS 131, extends northwest and then northeast to intersection of Lower Ridge Road and WIS 131 in the village of Ontario.
Length: 8.6 miles **Surface:** Paved

This route offers many scenic views including Wildcat Mountain State Park, Amish farms, log cabins, a round barn and examples of contour farming.

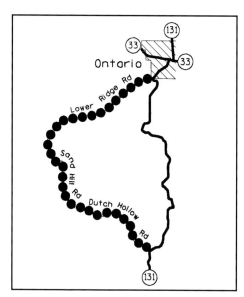

R-57

Location: Waupaca County. South Foley Road and Town Line Road between US 10 and WIS 54.
Length: 4.1 miles **Surface:** Paved

The Ice Age National Scenic Trail follows this route and a log house for hikers is located on the South Foley Road segment. Its scenic beauty is enhanced by rolling hills and an arch of trees over the road at two points. Deep ravines directly off the road are accented with ferns and a variety of wildflowers. Bluebirds and others are regular visitors to the large apple orchard along both sides of South Foley Road. The Waupaca River flows alongside part of the road and the rapids can be heard at the Cobbtown Road bridge.

R-58 & R-59

Location: Oneida County. R-58: Blue Lake Road west from US 51 to Mercer Lake Road, then north to WIS 70. R-59: Sutton Road and Camp Pinemere Road between WIS 70 and Blue Lake Road.

Length: R-58: 9.6 miles R-59: 4.5 miles

Surface: R-58: Paved
R-59: Paved, gravel & sand

R-58: Skirts many scenic lakes as it wanders through thick pine and hardwood forests. Crosses a railroad beds used in the 1800's that has now been converted to the Bearskin State Trail for hiking and bicycling. R-59 can be characterized as a northwoods wilderness road. Along this route you will see original log cabins used by some of Minocqua's first homesteaders.

R-60

Location: Vilas County. County Highway K, between County Highway N and County Highway M.

Length: 11.7 miles

Surface: Paved

This winding route travels through the 220,000 acre Northern Highland American legion State Forest. Canopies of coniferous and hardwood trees enhance the scenic beauty of R-60 as it passes near old logging camp sites, hiking trails, and an old saw mill located in Star Lake. The entire stretch of this scenic drive traverses heavily wooded area abundant with wildlife. R-60 offers frequent scenic vistas of numerous, clear northwoods lakes and dense forest land.

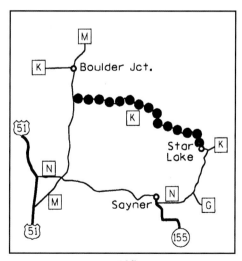

R-61

Location: Outagamie County. County Highway MM between County Highway M and Wisconsin Highway 76.

Length: 3.3 miles

Surface: Paved

This road features an interesting combination of historic and scenic features. Many wooded areas, wetlands and agricultural uses are adjacent to the road's 3.3 mile course. R-61 crosses several streams and stretches along several wetland areas that are part of the Wold River Watershed. Several large white pines can be spotted along this road, often in combination with large stands of trees.

R-62

Location: Price County. County Highway RR, begins at the intersection of County Highway C, north-easterly to the intersection with Wisconsin Highway 86.

Length: 2.0 miles **Surface:** Paved

Although short in distance, this rustic road is long in aesthetic quality. It offers the only access to Timms Hill County Park, the highest point in the state of Wisconsin. The road serves year-round tourist traffic including the ski trails and the Ice Age Trail. Two small lakes also border the road, undoubtedly placing them among the highest lakes of Wisconsin.

R-63

Location: Sheboygan County. County Highway S, beginning at the intersection of WIs 23 north to the Town of Glenbeulah.

Length: 2.4 miles

Surface: Paved & gravel

County Highway S rests on the remains of glacial sand and stone, some of which is 10,000 years old. Winding north from WIS 23, one can see the remains of old farmland being re-claimed by the trees and shrubs since glacial soil made farming difficult. The last portion of the road is made of old forest and steep Kettle Moraine hills and curves. The Rustic Road route ends at the village limits of the historic Village of Glenbeulah. The Wade House State Park and the Wesley Jung Carriage Museum are located nearby.

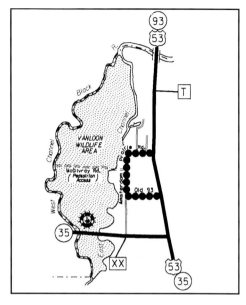

R-64

Location: La Crosse County. Northwest of Holmen, makes a loop off US 53/WIS 93 & follows Amsterdam Prairie Road and Old 93.

Length: 2.7 miles **Surface:** Paved

Located near the Van Loon Wildlife Area, this route passes scenic vistas of bluffs, prairie farms, deciduous trees and coniferous windbreaks. From Amsterdam Prairie Road it is possible to enter on foot historic McGilvray Road, also known as Seven Bridges Road and on the National Register of Historic Places because of the rare bowstring arch construction of the bridges.

R-65

Location: Ozaukee County. Between Wauwatosa Road and Granville Road in the City of Mequon.
Length: 2.0 miles
Surface: Gravel

Hawthorne Road is the only gravel road currently left in the City of Mequon. More than half of it is lined with oak, maple and weeping willow trees which provide a canopy in the summer and a blaze of color in the fall. Open land along R-65 is under cultivation or serves as pasture land for horses and sheep, providing for pleasant agricultural vistas.

R-66

Location: Lafayette County. Just off County Highway W in Town of Benton, follows portions of Buncombe, Kennedy, Beebe and Ensch Roads.
Length: 7.5 miles **Surface:** Paved

Beautiful scenery and history distinguish this Rustic Road, located in the unglaciated "driftless" area of southwestern Wisconsin. In autumn, R-66 provides spectacular sights of the fall harvest and colors. An abandoned lead mine complete with tin shacks, rusted ore buckets and tailing piles are visible from Kennedy Road.

R-67

Location: Barron/Polk Counties. Portions of Pine Road, 13-3/4 Avenue, West County Line Road and 16th Avenue, forming a loop from US 8 to US 63.
Length: 4.57 miles
Surface: Paved & gravel

R-67 winds through woods and wetlands, along fields and forests, and around the edge of Skinaway Lake. Wildlife and wildflowers abound. This route provides a quiet, natural and picturesque adventure through the northwestern Wisconsin countryside.

About The Authors

Norbert Blei

Norbert Blei, Chicago native and author of a trilogy concerning that city and its people – *Chi Town, Neighborhood* and *The Ghost of Sandburg's Phizzog* (an award-winning collection of short stories) – has lived in Door County, Wisconsin, since 1969 and has written extensively about his adopted state as well.

Norb has taught, lectured and given writing workshops throughout the state and the Midwest, and is the Writer-In-Residence at The Clearing, a retreat for practitioners of the creative arts in Ellison Bay. There he has guided beginning and advanced students in the art of fiction, nonfiction and poetry for more than twenty years.

Norb's work has been published in many of the state's leading periodicals and literary magazines, and he is an occasional commentator and frequent guest on Jean Feraca's *Conversations* show on Wisconsin Public Radio. In 1985, the Wisconsin Library Association honored his literary contributions by designating him a Notable Wisconsin Author and he is included in Jim Stephens' three-volume literary history of Wisconsin, *The Journey Home*.

Jean Feraca

Poet, journalist and professional speaker, Jean Feraca is perhaps best known as host of her daily talk show on Wisconsin Public Radio. Well-read, insightful and unconventionally inquisitive, she finds the unique in the everyday and the siblime in simplicity.

Her talents extend to literary efforts, and 20 years of publication and public presentation of her work is represented by her books *South From Rome, Il Mezzogiorno* and *Crossing the Great Divide*. The latter was nominated for a 1994 Pushcart Prize.

Jean grew up in a New York household with a father

who was fond of reciting poetry and reminding her of the importance of her Italian heritage. After graduate work at the University of California she took off for Rome, where she lived and taught for over two years and traveled extensively. Dubbed "one of the most promising poets of her generation" by Grace Schulman, poetry editor of *The Nation*, Jean has received numerous national prizes, including the 1975 Discovery Award.

Ben Logan

Born in 1920, Ben Logan is a broadcast media producer by trade, and a freelance writer of magazine articles, screeenplays and books. His work has been compared to that of another famous Wisconsin writer, Hamlin Garland, for its skillful composition and faithfulness to the truths of life in the state. Ben's writing reflects his Depression-era boyhood on a farm near Seneca and Mount Sterling, in the southwest corner of the state near the Mississippi River. It follows that he and Garland would be compared, since Garland grew up on a farm only forty miles north, near West Salem.

Farm life and an isolated childhood permanently imprinted itself on Ben's psyche, as evidenced by the subject of his most well-known work, a classic tale of life on a Midwest farm, *The Land Remembers*. The connection made between author and reader is also evident in the success of this autobiography. For almost twenty years, the book has endeared itself to readers everywhere with its collection of charming character sketches and realistic portrayals of honest work and decent folks. It was recently reprinted in a heavily illustrated collector's edition and has also been issued as an audio book.

Bill Stokes

Born in Barron, Wisconsin on September 11, 1931, Bill Stokes grew up on a small dairy farm between Barron and Rice Lake. He began his official writing career as an outdoor writer and general reporter for the *Stevens Point*

Daily Journal, where he served as columnist, reporter and outdoor writer. In 1969, the *Milwaukee Journal* became his venue as a feature writer and columnist, and he found new ground to cover in 1982 at the *Chicago Tribune.* After eleven years there, Bill retired to pursue freelance projects.

During his long journalism career, Bill won many conservation awards, including the Ernie Pyle Memorial Award from Scripps-Howard News Service in 1972. His work has appeared in many national publications, among them *Reader's Digest, Outdoor Life* and *Sports Afield.* He has compiled three anthologies of his newspaper writing and authored two children's books.

Bill has lived on Madison's west side since 1959, a home he shares with his wife Betty. They have a 45-acre "Back 40" on a trout stream near Westfield, where Bill engages in his hobbies of trout fishing, photography, bicycling and grandfathering. (They have five grown children and twelve grandchildren.) Bill and Betty also enjoy traveling.

George Vukelich

George Vukelich was an insightful and reverent admirer of Mother Nature and he honored our charge to walk gently with her. Many of his environmental essays have been collected in two volumes of *North Country Notebook.* He wrote two weekly newspaper columns, contributed to many magazines and newspapers, including *Wisconsin Trails* and *Wisconsin Outdoor Journal,* wrote three documentary films, and hosted "North Country Notebook," heard weekly on Wisconsin Public Radio.

George was honored by the Milwaukee Press Club and the Council of Wisconsin Writers, and he was given the Gordon MacQuarrie Award from the Wisconsin Academy of Sciences, Arts and Letters.

George also wrote a novel, *Fisherman's Beach,* about the life and struggles of a commercial fishing family on Lake Michigan. His short story, "Coming of Age," appears in *Harvest Moon: A Wisconsin Outdoor Anthology,* also from Lost River Press. ♣